HASLINGDEN
& HELMSHORE

THROUGH TIME

Chris Aspin &
John Simpson

AMBERLEY PUBLISHING

Acknowledgements

Most of the black and white photographs in this book have been chosen from the many hundreds given to Helmshore Local History Society since its formation in 1953. We are most grateful to the society for making them available and to the people who have supported the group in its efforts to record the district's past.

Picture credits

Fred Barlow: p 88 (lower); **Steve Beech:** p 54 (lower); **David Belshaw** (late Joe Belshaw): p 15 (upper), p 37 (upper); **Jo Bones:** p 5 (lower), p 6 (lower), p 9 (lower), p 10 (lower), p 13 (lower), p 15 (lower), p 16 (lower), p 21 (lower), p 26 (lower), p 27 (lower), p 29 (lower), p 30 (lower), p 31 (lower), p 35 (lower), p 36 (lower), p 38 (lower), p 53 (lower), p 60 (lower), p 69 (lower), p 70 (lower), p 72 (lower), p 74 (lower), p 75 (lower), p 78 (lower), p 80 (lower), p 81 (lower), p 83 (lower), p 86 (lower), p 87 (lower), p 89 (lower), p 90 (lower), p 91 (lower), p 92 (lower), p 93 (lower), p 95 (lower); **Frank Crook**: p 84 (lower); **Harry Cropper**: p 24 (lower); **David Graham**: p 47 (lower); **Bill Grimshaw**: p 94 (lower); **Marie Ives**: p 30 (upper); **Christopher Kirby** (late Arthur Kirby): p 25 (upper), p 40 (lower), p 41 (upper), p 42 (both), p 43 (lower), p 61 (lower), p 62 (lower); **Joy McCarthy**: p 76 (lower); **Victor Marcinkiewicz:** p 67 (lower); **Maxwell Photography:** p 19 (lower); **John Mort**: p 82 (lower); **Ian Redman:** p 11 (lower), p 23 (lower), p 32 (lower), p 33 (lower), p 35 (lower), p 44 (lower), p 46 (lower), p 48 (lower), p 52 (lower), p 56 (lower), p 71 (lower), p 79 (lower), p 85 (lower); **Eddie Roberts**: p 52 (upper), p 58 (lower); **David Rothwell**: p 26 (upper), p 55 (upper); **Malcolm Ward:** p 19 (lower); **Joshua Whelan**: p 41 (lower); **David Wynne**: p 7 (lower), p 37 (lower)

First published 2010

Amberley Publishing
The Hill, Stroud,
Gloucestershire, GL5 4EP
www.amberley-books.com

ISBN 978 1 84868 656 4

British Library Cataloguing in Publication Data. A catalogue record for this book is available from the British Library.

Typeset in 9.5pt on 12pt Celeste.
Typesetting by Amberley Publishing.
Printed in the UK.

Introduction

Haslingden, Lancashire's highest market town, and Helmshore, the village in the valley below, both have long histories. Prehistoric man left his mark on the landscape – the remains of a Bronze Age circle can be seen on Thirteen Stone Hill – but the earliest written records are from the thirteenth century. Henry de Lacy, Earl of Lincoln, enclosed parts of Alden and Musbury as a deer park in 1304-5, and from the Tor at its centre, he would have looked over a largely uncultivated landscape.

Significant growth began in the eighteenth century, when the hill farmers began to add to their income by weaving both woollen and cotton cloth for dealers. Spinning mills, powered first by water-wheels and then by steam, followed as textiles became the leading industry. Haslingden specialised in working up waste cotton from other factories; and Sunnybank Mill in Helmshore gained a world-wide reputation for its papermakers' felts, some of which were used in the printing of our bank notes. The quarrying of the hard-wearing millstone grit also became important, and local stone, as well as providing the main construction material for mills, houses, public buildings, roads and pavements, was sold to local authorities in all parts of the country. Bricks did not come into their own until the 1920s. During the Second World War, work carried out in great secrecy at Holden Vale on the outskirts of Helmshore, provided the RAF with a propellant for incendiary bullets that gave our fighter pilots a decisive advantage during the Battle of Britain. At the same time, the engineering firm of S.S. Stott, once renowned for its steam engines, was making components for PLUTO (Pipeline Under the Ocean) that was laid under the English Channel to supply Allied forces with oil after D-Day.

Local men to gain international recognition were William Cockerill (1759-1832) and his son John (1790-1840), who played a huge role in the industrial development of Europe. William, an inventor of textile machines, settled in Belgium, where John established the most

extensive iron foundry and machine manufactory in the world, and built there the Continent's first steam locomotive. Michael Davitt (1846-1906), the Irish patriot, spent his youth in the town, and Alan Rawsthorne, the composer, was born there in 1905. The world's first public IQ test was held in Haslingden in 1903, and four years later, Haslingden Corporation began operating one of the country's first municipal bus services.

Several of the world's leading cricketers have played for the Haslingden Club, which has been a member of the Lancashire League since its formation in 1892. They include George Headley and Clive Lloyd (West Indies), Vinoo Mankad (India) and Dennis Lillie (Australia).

Many mills, churches and chapels were demolished during the period covered by this book; and with them went the railway, the Town Council (now part of Rossendale) and, sadly, many of the strengths of a once close-knit community. A busy by-pass now links the district to both Manchester and the open countryside of north east Lancashire.

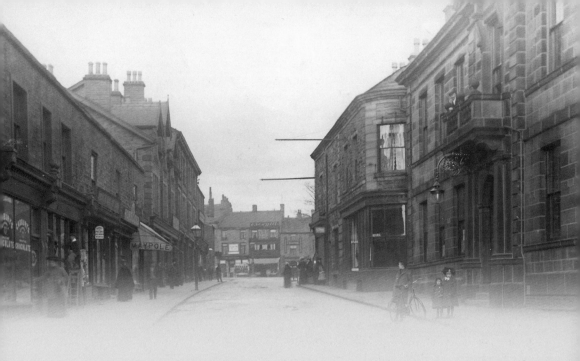

CHAPTER 1

Haslingden

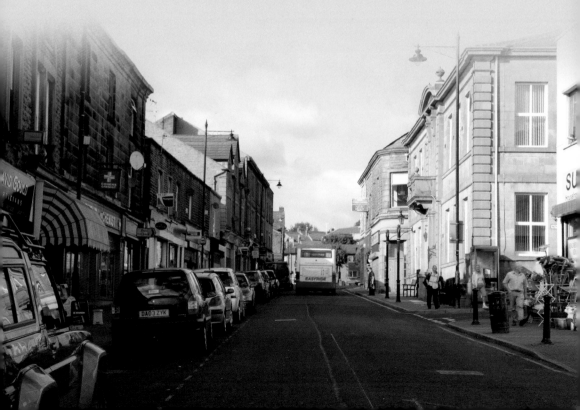

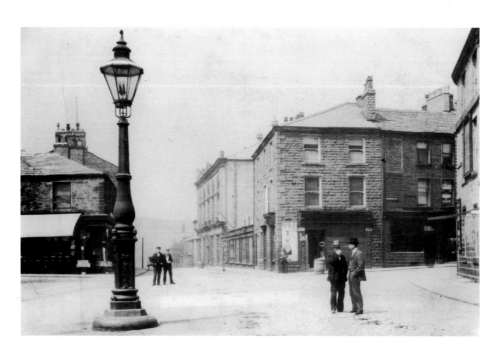

Market Place

Market Place, the old centre of Haslingden, photographed on a quiet day in 1908. The Big Lamp, a magnet for public gatherings, was erected by the Haslingden Gas Company in 1841 and removed as a traffic hazard in 1962. After some years in private ownership, it went by mistake for scrap just as plans were being made to return it to the top of Deardengate. The Public Hall in the middle distance was opened in 1868, and the Trades Club, at the corner of Church Street and Regent Street, was built in the 1840s by the radical Dr Binns, as a house and surgery.

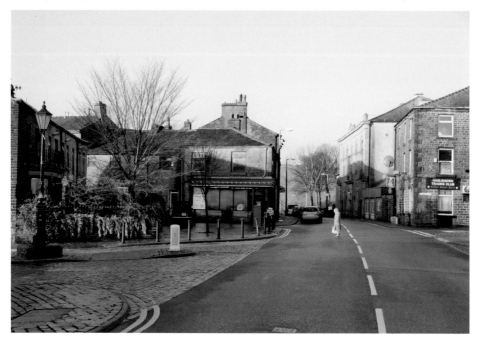

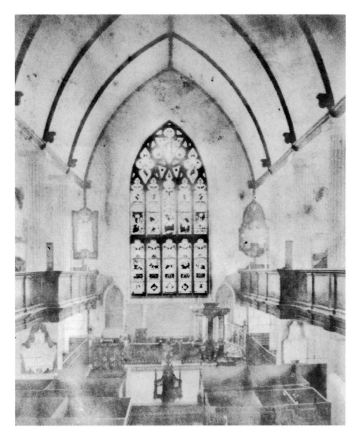

The Parish Church

Some of the earliest photographs to have come down to us were taken in the parish church. The view of the east end right dates from between 1866 (installation of the large window commemorating Jane, wife of John Hoyle of The Lindens) and the removal of the box pews in 1878.

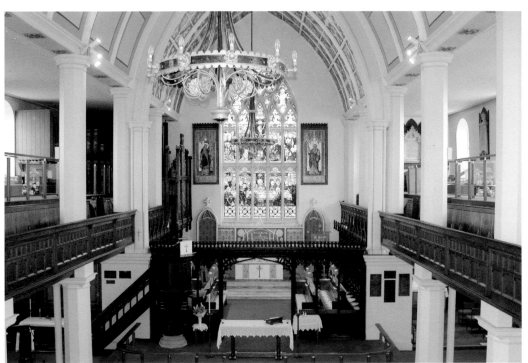

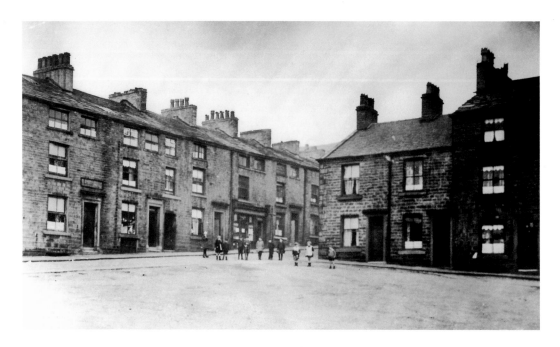

President's Visit

Haslingden is one of the few towns in Great Britain to have been visited by a head of state. The Irish President, Mary McAleese, came specially in 2006 to take part in the week-long celebrations to mark the centenary of the death of Michael Davitt, the Irish patriot, who grew up in the town. The Davitt family lived in Wilkinson Street, part of which is seen in the older photograph. The President laid flowers at a memorial on the site.

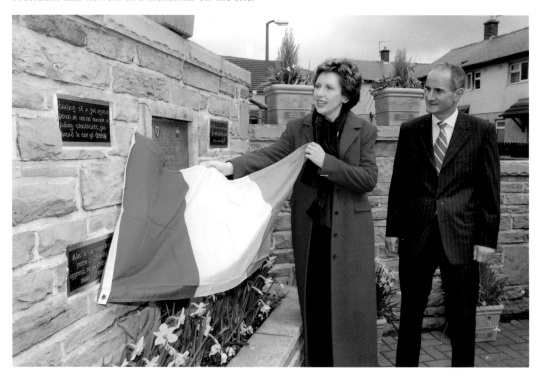

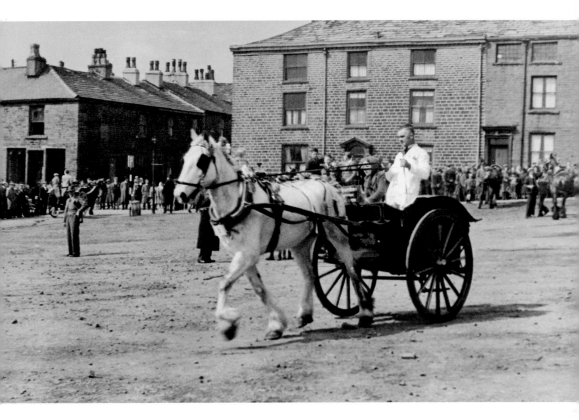

Marsden Square

Handloom weavers were among the first residents of the eighteenth century houses that overlooked Marsden Square for two centuries. Residents saw public meetings, fairs, circuses and May Day parades, such as that promoted by Haslingden Young Farmers' Club in 1949. Driving the milk float is J. B. Feathers, of Slack Head Farm. The square is now built over.

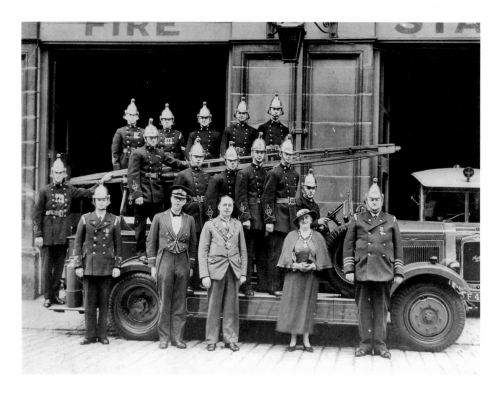

The Fire Brigade

For many years, the Haslingden fire station was next to the Public Hall in Regent Street. The annual inspection in 1935 was made by the Mayor, Coun. Fred Brandwood. On his right is James Souter, the Mayor's Attendant. Oates Maden, the Fire Chief, is standing (right). Lancashire Fire and Rescue Service now have their base in Manchester Road and are called out about 200 times a year.

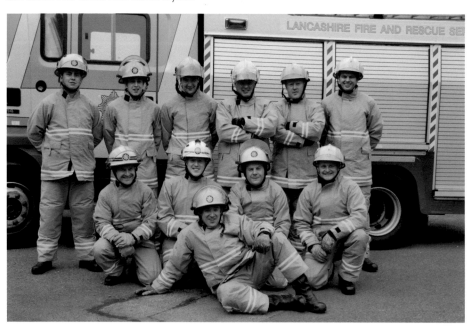

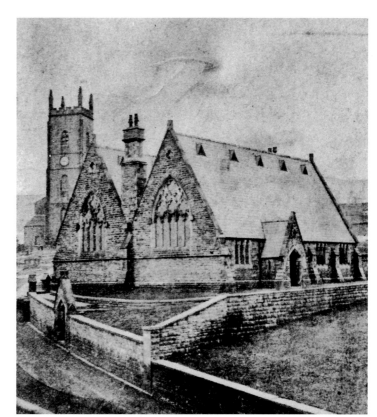

St James's Day School
The explorer Dr
Ralph Holden, who
died in Africa in 1861,
photographed St
James's Day School
shortly before setting
out on his final
expedition and soon
after its completion in
1855. Fire destroyed
the building in January
1979. The new school
was built in nearby
Regent Street.

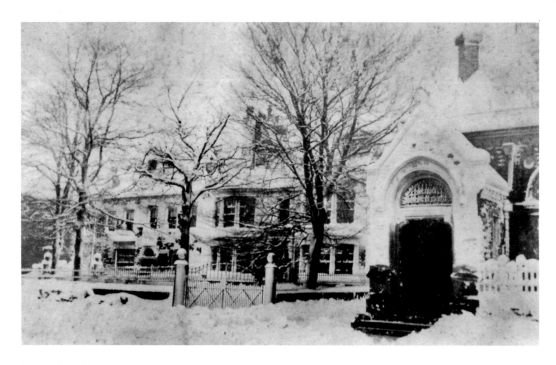

The Old Vicarage

Higher Deardengate on a winter's day in the 1870s. The handsome building beyond the trees, having been the home of John Lonsdale, a merchant, was the vicarage from 1813 to 1887. In later years, it was a laundry, the Empire Cinema (1911-1966) and a bingo hall before becoming a supermarket.

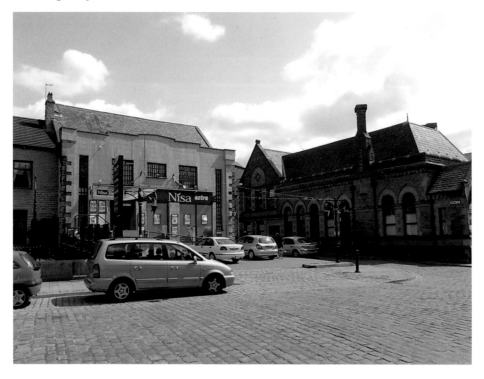

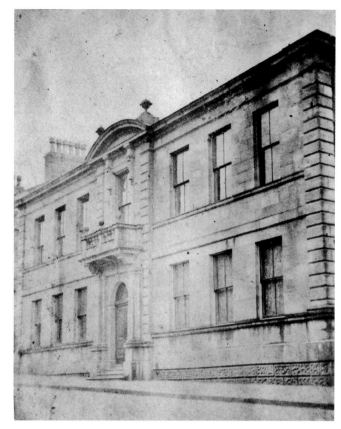

A Link with a Patriot
The Mechanics' Institute, now the Public Library, shortly after its completion in 1860. Among its first students was Michael Davitt (inset), the Irish Patriot, who spent his youth in the town. At the Institute, he read the history of his native country and determined to devote his life to reform. The drinking fountain at the lower side of the building was the gift of Dr. Binns in 1869. He had led the campaign for a free public library for the town in the 1850s.

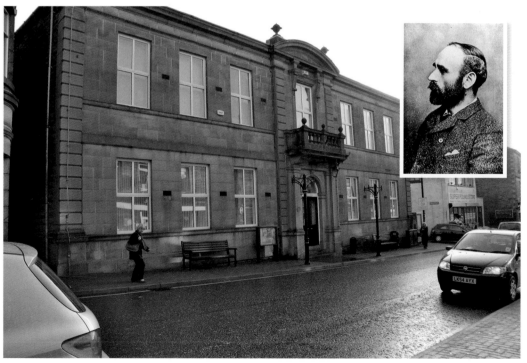

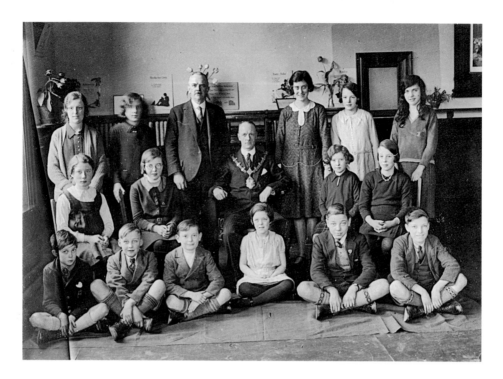

Changes at the Library

Haslingden Library has been at the centre of the town's cultural life since it was built as the Mechanics' Institute in 1859-60. A children's library opened in February, 1931. Every school in the borough sent representatives, seen here with the Mayor (Ald. A. S. Watson), the Chairman of Libraries (Ald. Tom Howarth) and the Librarian, Miss Ivy Hill. The library underwent a major facelift in 2008.

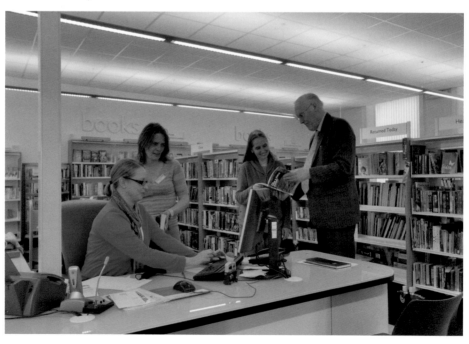

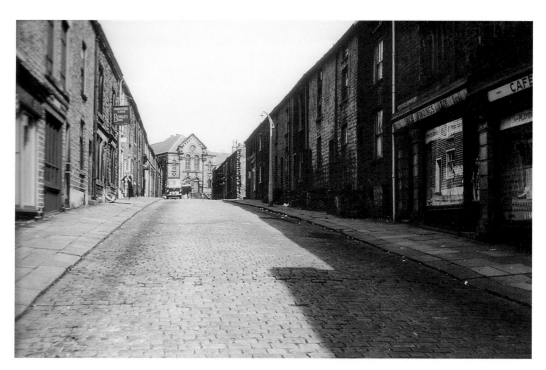

Pleasant Street

Only the lower section of Pleasant Street, which linked Higher Deardengate and Bury Road survives; and Ebenezer Baptist Church, beyond the far end of the street, has been much reduced. Many of the so-called Club Houses in the street were built by a terminating building society. The Foresters Arms (Th' Owd Tack) on the left was originally called Hark to Tackler after a dog owned by William Turner, the Helmshore mill master and magistrate.

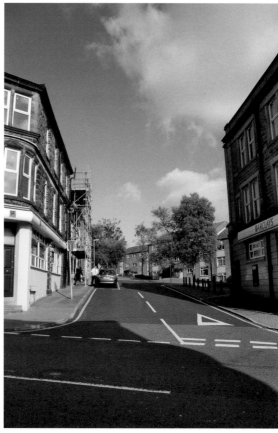

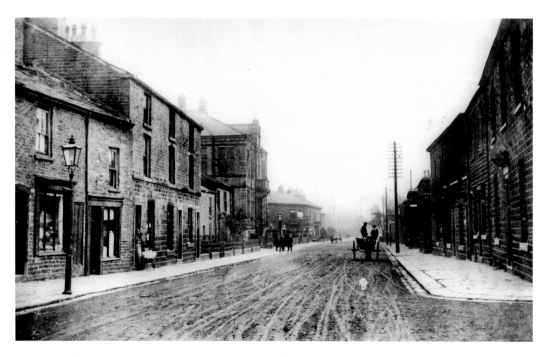

Bury Road

Bury Road, pictured here in 1905, was Haslingden's main town centre thoroughfare until 1826, when Manchester Road and Blackburn Road were built to provide traffic with an easier gradient than Back Lane and Hudrake. On the left is the Technical (later Grammar) School, opened in 1904 and demolished in 1997. During the 1840s, this part of the road was known as Causeway.

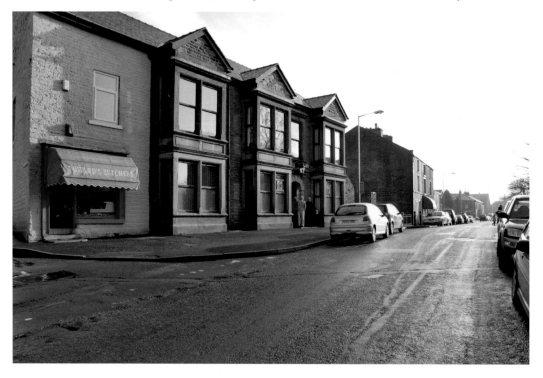

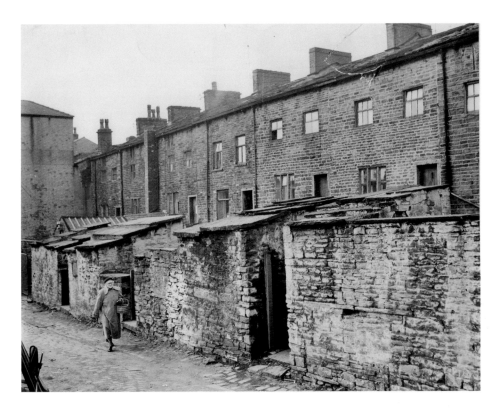

Central Square

Far Back Pleasant Street in 1964, shortly before its demolition to make way for the Central Square flats. The houses, built for handloom weavers, were back-to-back with those in Pleasant Street. Indoor toilets were unknown when these houses were built in the early 1800s. Residents had to cross stone-flagged yards to reach water closets.

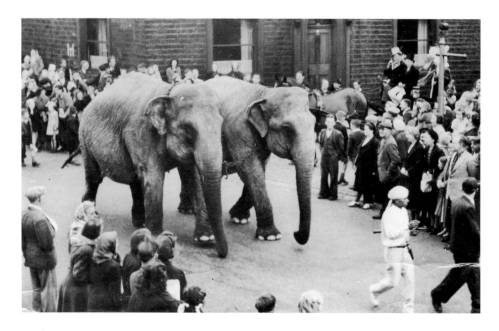

Trunk Road

The circus comes to town. Elephants near the junction of Bury Road and Pleasant Street are being led by their Indian trainer during carnival week in 1950. 'Ringland's Famous Circus' gave two performances on St. Peter's Playing Fields on 4 September. A more solemn event took place at the Municipal Offices on Bury Road on 18 April, 1964. Pictured are the Mayor (Coun. Tom Waller), aldermen, councillors and officials during a ceremony to grant the freedom of the borough to the 4th Battalion, the East Lancashire Regiment (TA), which has had a long association with the town.

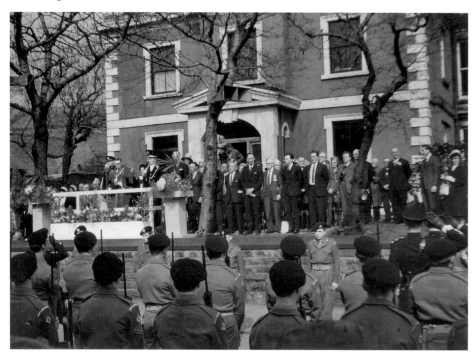

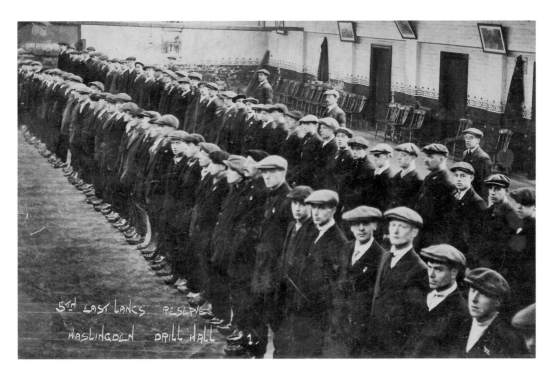

'Defence, not defiance'

Volunteers parade in the Haslingden Drill Hall on the outbreak of the First World War. They joined the East Lancashire Regiment. The Drill Hall is now used by the Army Cadet Corps, which draws youngsters, both boys and girls, from the three Rossendale towns.

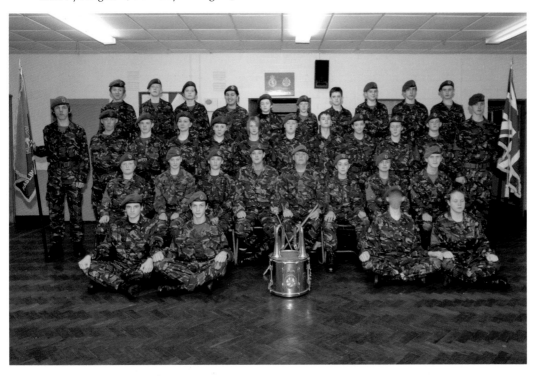

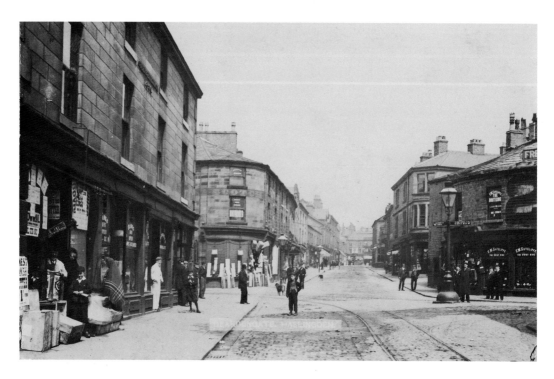

The Town Centre

The present town centre has seen many changes, most notably the building of the former Midland Bank at the corner of Blackburn Road and Higher Deardengate. The gas lamp was removed in September, 1907.

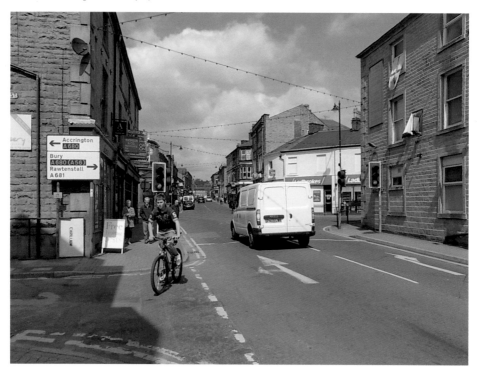

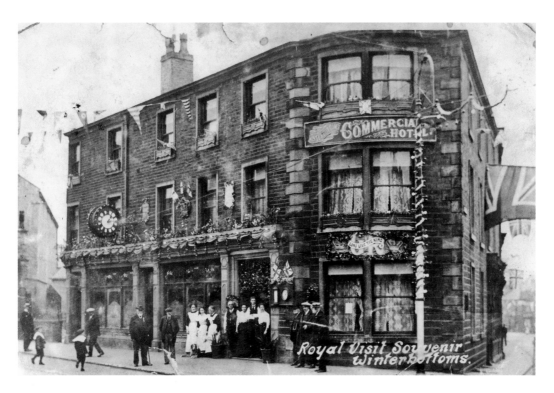

The Commercial

The Commercial Hotel dates from about 1830. It is seen in the older photograph decorated for the visit of King George V and Queen Mary in 1913. The proprietor, Robert Winterbottom and his staff pose outside the main entrance for the souvenir postcard.

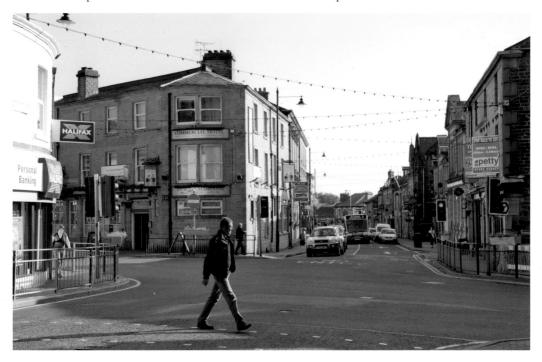

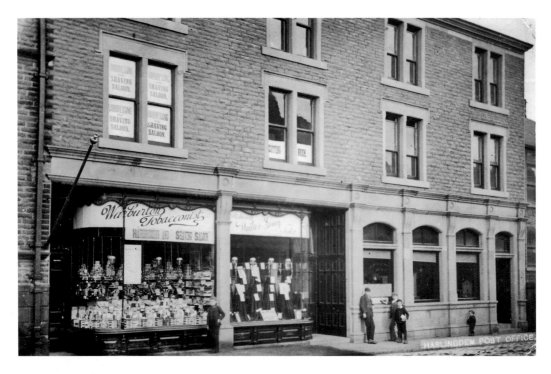

The Post Office

Haslingden's main post office moved to Lower Deardengate from Regent Street in 1904, when the older photograph was taken. Tattersall Warburton, tobacconist, and Walter Gray, tailor, had shops in the building. The post office expanded in 1923 by taking over the two businesses, and vacated its original part of the building in 1936.

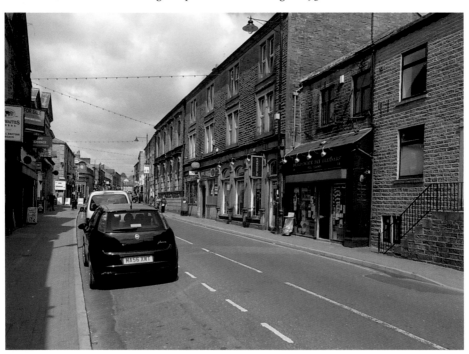

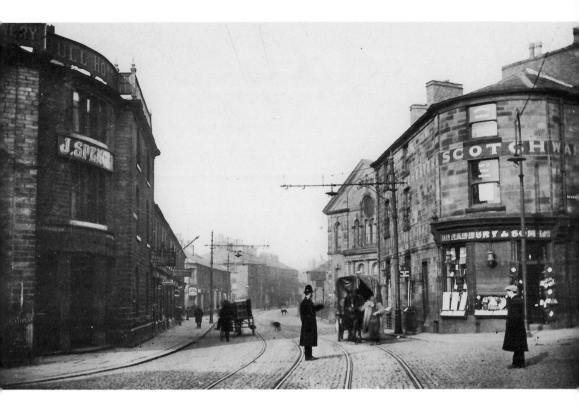

Directing Traffic

The town centre seen in 1915 and 2010. A policeman directs the traffic, all of it horse-drawn, in the older photograph. Traffic lights came into use at the junction in September, 1931. For some years they were switched off at 11pm. A bank replaced Bradbury's store on the right in 1920 and Trinity Baptist Church was demolished in 1969.

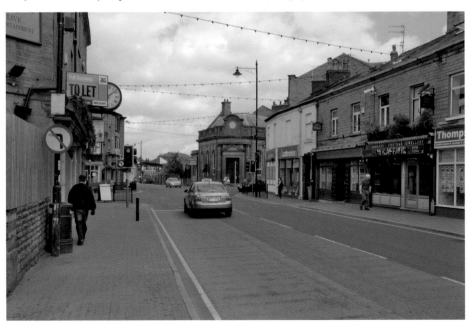

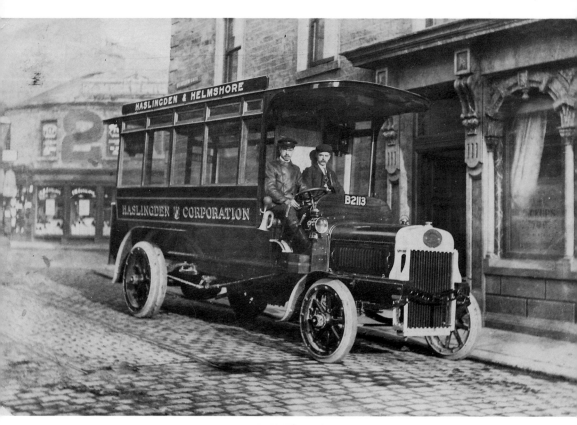

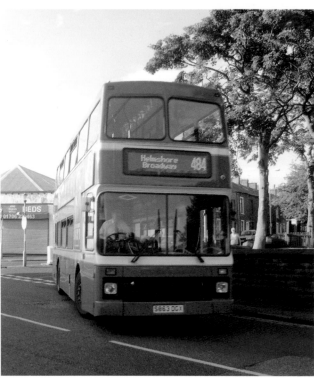

A Century of Bus Travel

On 11 November, 1907, an eighteen-seat Leyland bus with solid rubber tyres made fourteen journeys between the Commercial Hotel, Haslingden and Helmshore Station to inaugurate one of the first municipal services in Britain. The service lost money and closed in July, 1909. Buses have run without interruption since 1920. Rossendale Transport, which took over the Haslingden and Rawtenstall fleets, marked the centenary of the Helmshore service in 2007 by painting a double-decker in the Haslingden livery.

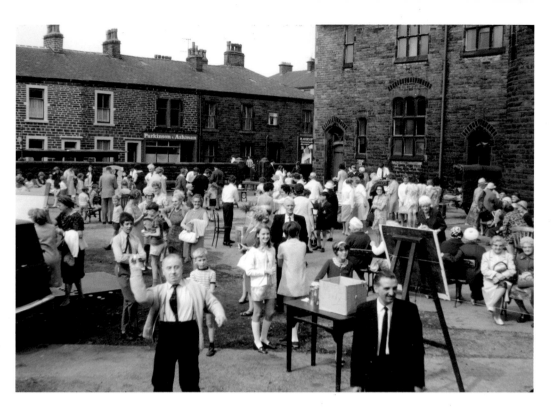

Methodists in Merry Mood

Members of Manchester Road Methodist Church enjoying a garden party in 1970. The former day school, opened in 1862, was demolished in 1975 to make way for the Health Centre. Michael Davitt, the Irish patriot, attended the school and it was there in 1903 that one of the world's first public IQ tests was taken.

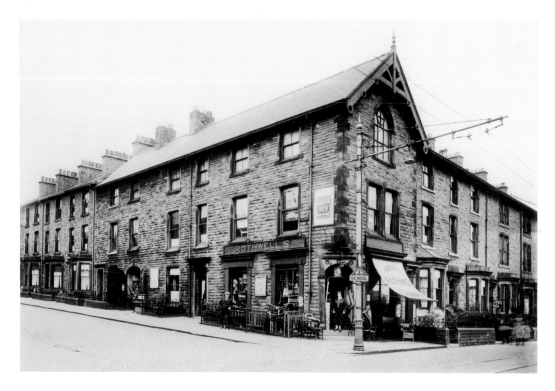

Park Street

Ladies' hairdressing is the latest use for the building at the corner of Park Street and Manchester Road. The older photograph was taken in the 1920s, when Leslie Dawson sold household furnishings. Before that, J. H. Anderton & Sons, ran a chip range and ironmongery business there. The world owes Anderton a great debt. Chip shops with their offensive smells regularly got into trouble until Anderton devised a way of burning the fumes. The rest, as they say, is history.

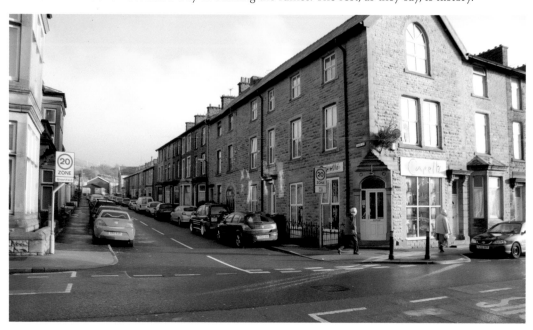

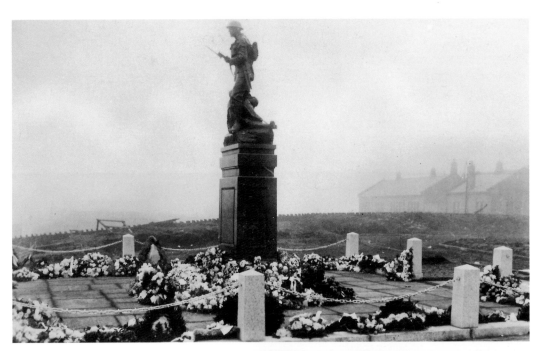

The War Memorial
Haslingden remembered the
Servicemen of the First World War
by laying out Greenfield Gardens and
commissioning from the sculptor
L. F. Roslyn 'Courage', a bronze figure
of a soldier with a wounded comrade
at his feet.

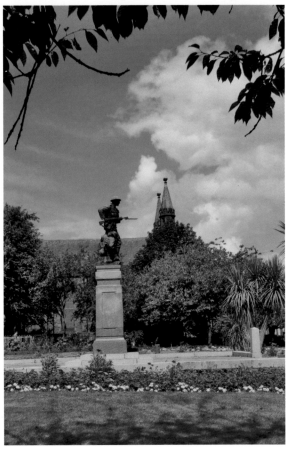

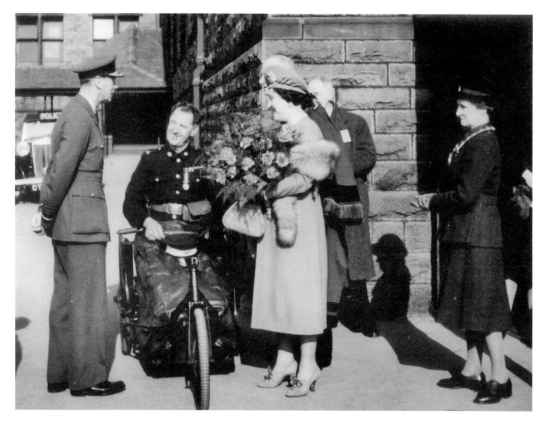

Royal Visit

King George VI and Queen Elizabeth visited Haslingden on 8 March, 1945, as the Second World War entered its final phase. They met townsfolk, including Fred Hutter, in the yard of Haslingden Council School. Below: a sunny day in the schoolyard in September, 1974.

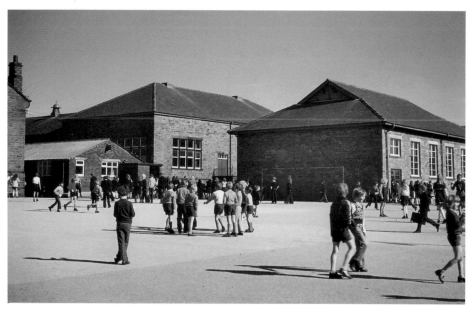

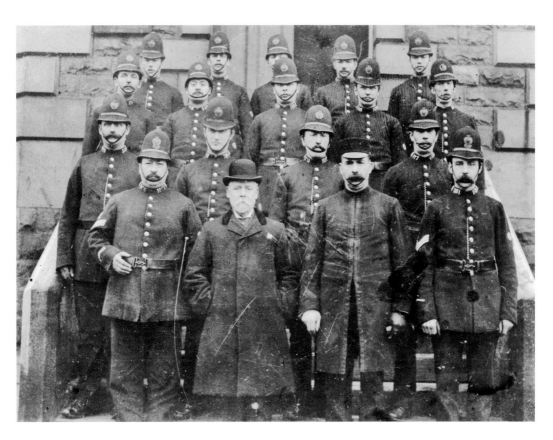

The Boys in Blue

Policemen have kept order in Haslingden since 1840. The older picture, taken in 1900, shows the force outside the now-vanished police station and court house in George Street. The present station in Manchester Road was opened in the 1960s.

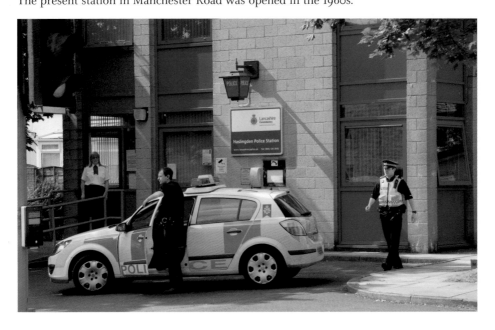

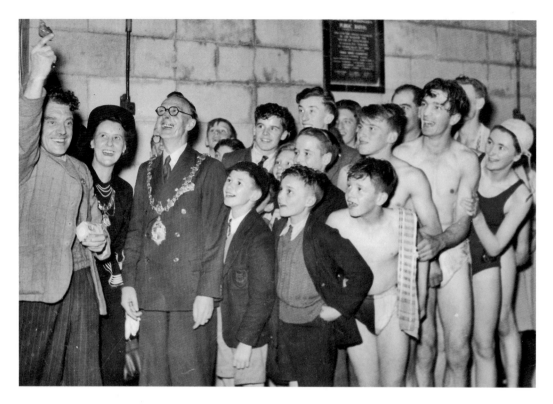

In the Swim

Sixty years separate these photographs taken at the Public Baths. Holding up a plastic chicken – his booby prize for the veterans' race at the Swimming Club's gala in 1949 – is Fred Clark. The Mayor and Mayoress, Coun. and Mrs Joe Ratcliffe, are among the amused spectators.

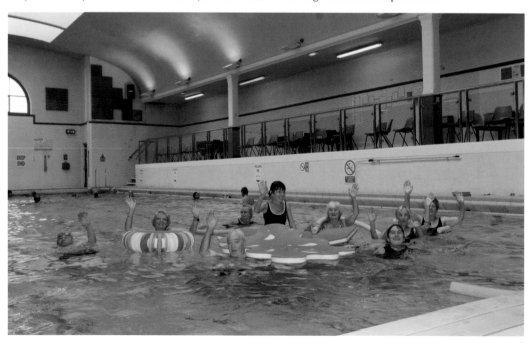

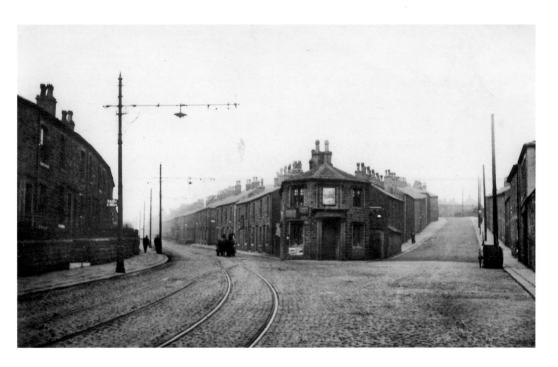

Junction Toll Bar
The old toll bar house at the junction of Manchester Road and Bury Road, demolished in 1924, reminds us that the owners of carts, coaches, carriages and other vehicles had to pay to use the privately-owned turnpikes until the late nineteenth century. When the picture was taken in the early 1900s, the building had become a shop, and trams ran along Manchester Road.

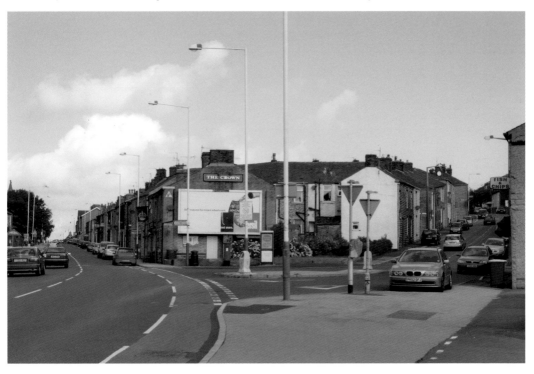

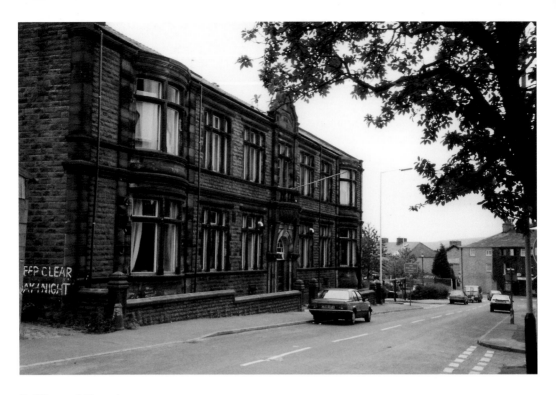

Politics and Shopping

The Conservative Club, opened in John Street in 1909, has been replaced by a Co-operative store. The car park replaced the tram (later bus) shed.

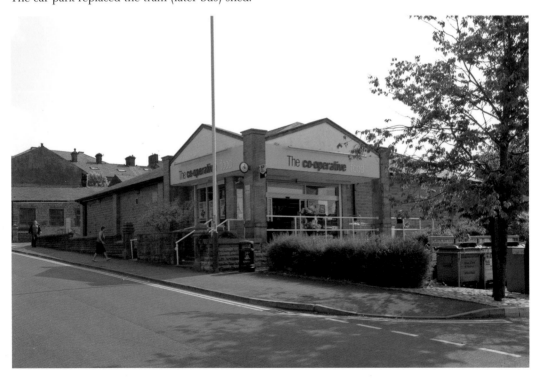

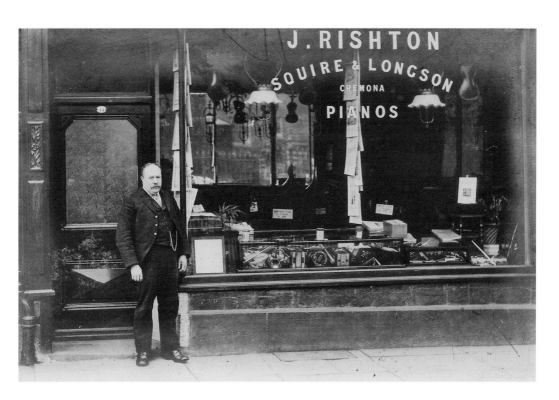

Harmony in Blackburn Road

John Rishton, music and musical instrument dealer, outside his shop, 14 Blackburn Road, in 1909. He died in 1928, having been a violinist with the Haslingden Orchestral Society since its formation in 1885. His shop is now part of the Haslingden Discount Store.

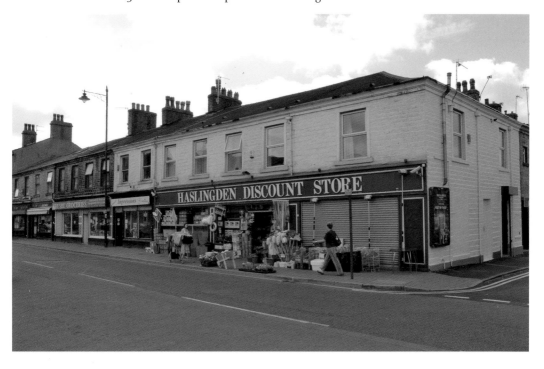

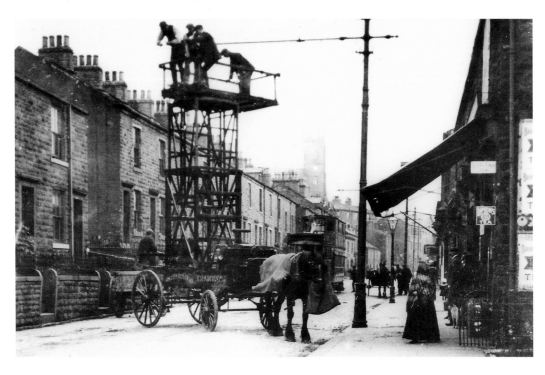

Blackburn Road
A steam tram waits in Blackburn Road while workmen adjust the arm of a tall pole in readiness for the switch to electric cars in 1908. Buses replaced the trams in 1930.

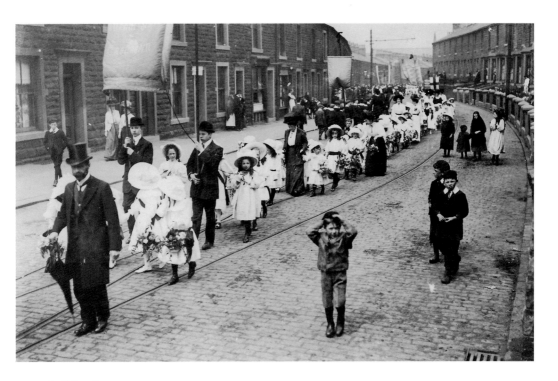

Walking Day

Walking days, during which church and chapel members paraded the streets, were a colourful feature of Lancashire life, especially during the nineteenth and twentieth centuries. Here we see the St. James's procession in Blackburn Road in about 1907. Some houses have been demolished but the survivors have been cleaned to reveal the pleasing colour of the original stone, which came from the once-famous local quarries. Note the lack of a footpath in the older picture and the modern emphasis on refuse collection.

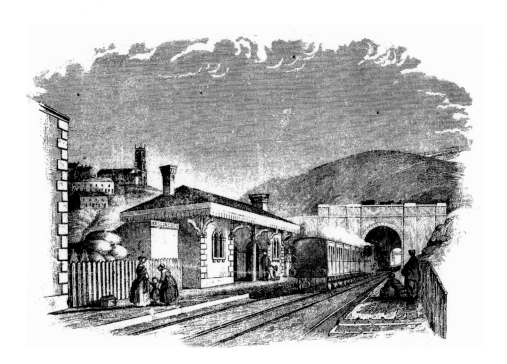

Railway and Motorway

The Haslingden by-pass between Grane Road and Rising Bridge follows the line of the railway track put down in 1840s. The Transport Minister, Kenneth Clarke MP, officially opened the road 4 December, 1981. To build the by-pass, which cost £10.8m, engineers demolished sixty-two houses and removed the North Hag and its tunnel. Both can be seen on the engraving of Haslingden Station made in 1849. Exactly 100 years later, Haslingden Corporation drew up plans for a by-pass that would have run parallel to the railway.

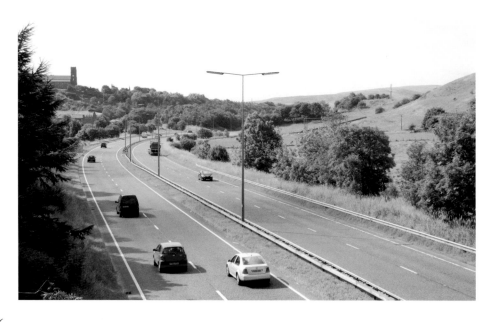

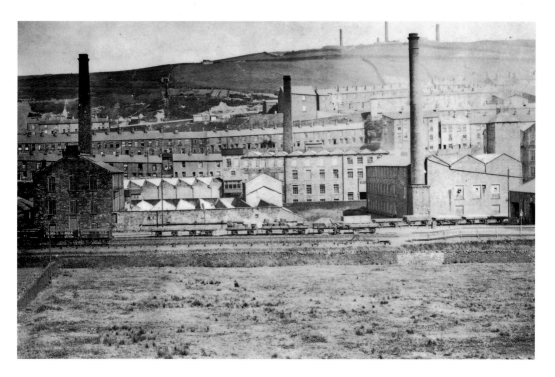

When Cotton was King

The mills in the older picture – (l-r) Britannia, Albert and Victoria – began work in the 1850s, when the cotton trade was booming. On the horizon are the chimneys of Top o' th' Slate brickworks, which operated for about twenty-five years until 1900. The site has been landscaped and features the panopticon known as The Halo. The Haslingden by-pass has replaced the railway, and Britannia and Victoria Mills have found new uses.

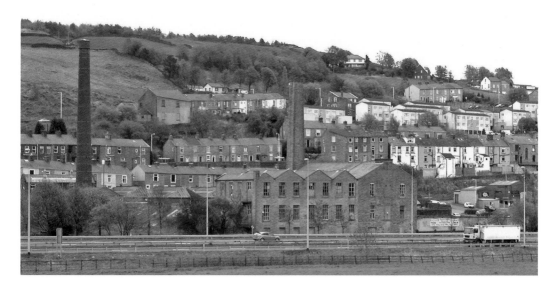

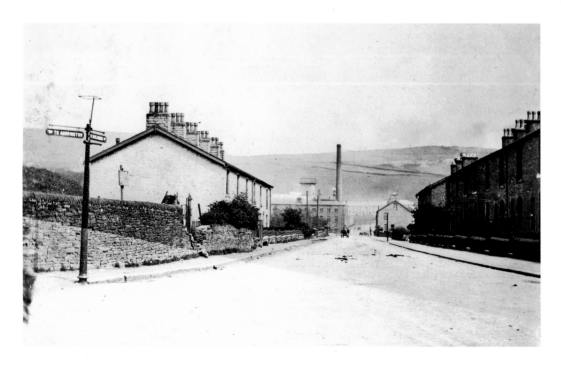

Hud Hey

Hud Hey Road near the junction with Rising Bridge Road in the 1920s. For well over a century the lower part of the road was dominated by Clough End Mill and its tall chimney. When foreign competition hit the cotton trade, the mill closed in 1962, throwing more than 100 people out of work. Several houses were demolished to make way for the Haslingden by-pass, which goes under the road.

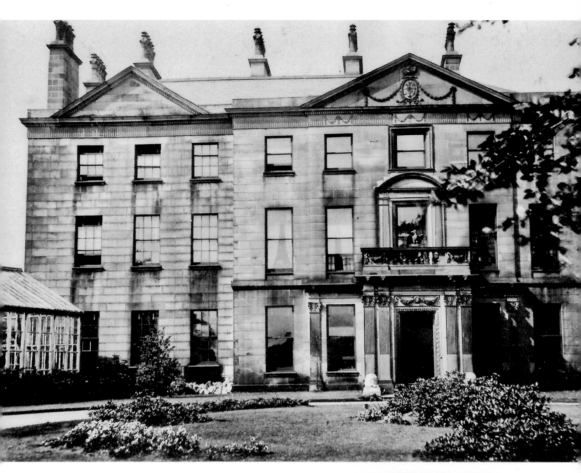

Carter Place

For most of its existence, Carter Place Hall was a mill family mansion. The Turners, founders of the large Helmshore woollen business, owned the building from 1807 to 1907 and were followed by the Worsleys, who made their fortune in cotton. Carter Place was used as the Gradgrind family home in a BBC production of Charles Dickens' *Hard Times*. A campaign to save the building failed and, except for the porch, it was demolished in the 1980s. By then the grounds had become an estate of mobile homes.

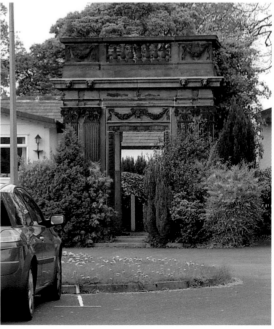

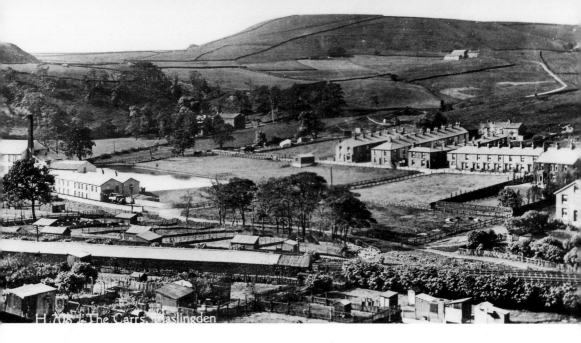

H.705 - The Carrs, Haslingden

The Carrs Transformed

The Carrs district of Haslingden has seen more changes than any other. Houses, Carr Hall cotton mill and the adjoining fields have given way to an industrial estate served by the Haslingden by-pass. The very long building in the older photograph was the Prinny Hill Steam Rope Works, close to the railway. The bottom picture shows the district in 1988.

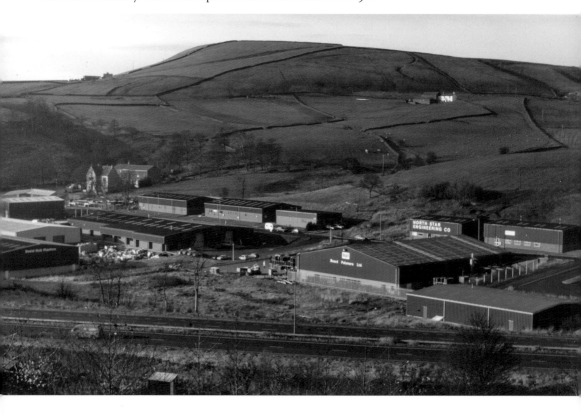

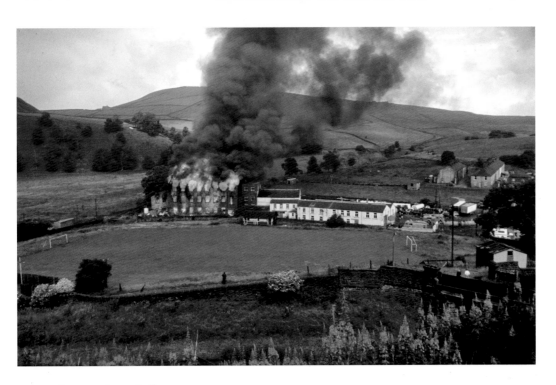

Inferno and Football

Arthur Kirby's dramatic photograph of fire destroying Carr Hall Mill (Lambert's) in August, 1978, also shows the Prinny Hill football ground used from 1935 until that year by St Mary's FC. When the Haslingden by-pass was built, the contractor dumped spoil to create the present ground adjoining South Shore Street. The bottom picture shows the Reserves (green and white) playing Garstang in 2010.

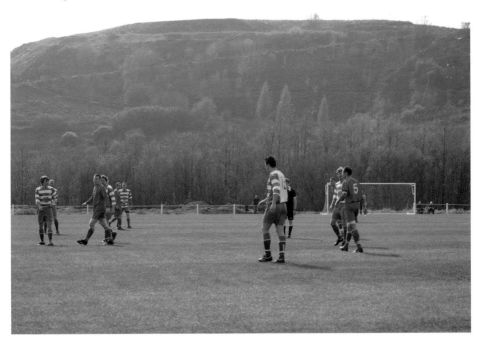

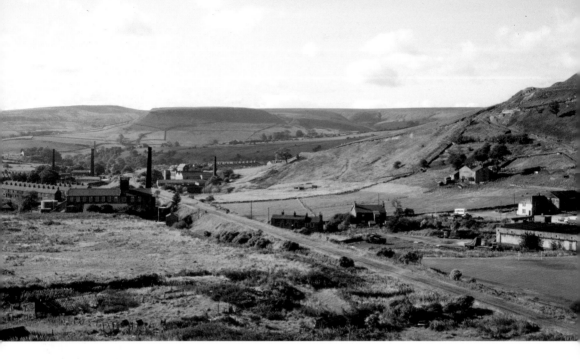

The Tor from Lincoln Street

Musbury Tor photographed by Arthur Kirby from Lincoln Street in October, 1974, and from the same spot in April, 1984. During that time, the disused railway track had become part of the Haslingden by-pass.

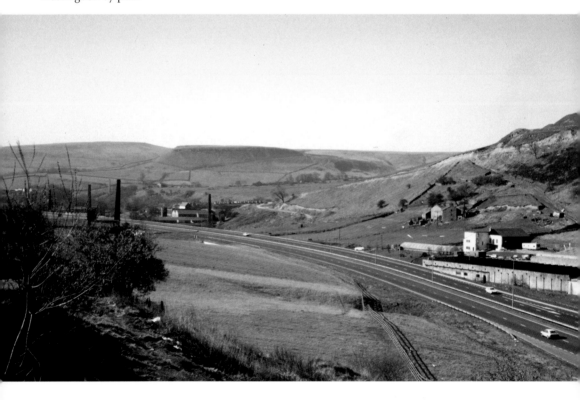

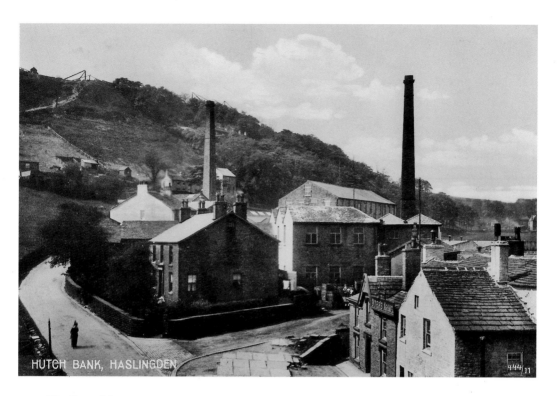

HUTCH BANK, HASLINGDEN

The Dyers' Arms
Among buildings demolished to make way for the Haslingden by-pass, the Dyers' Arms was one of the oldest. The pub, better known as The Flip, owed its real name to the nearby Hutch Bank dye works, which was started in the mid eighteenth century.

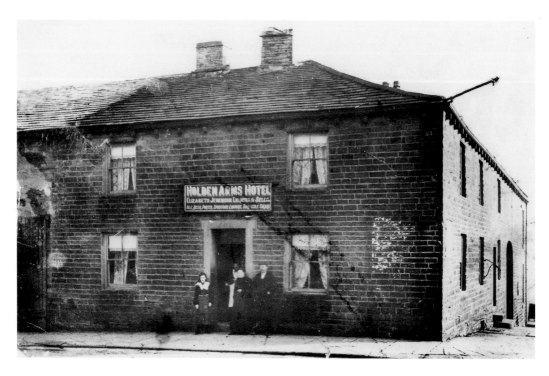

The Holden Arms

The Holden Arms dates from the early nineteenth century and was built to take advantage of the passing trade at the junction of two turnpike roads. The older photograph, taken in about 1907, shows Elizabeth Jenkinson, the landlady, and other members of her family at the entrance.

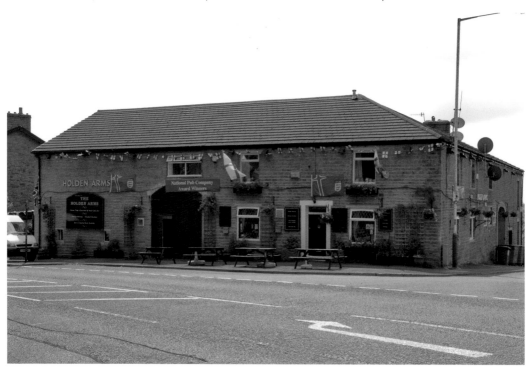

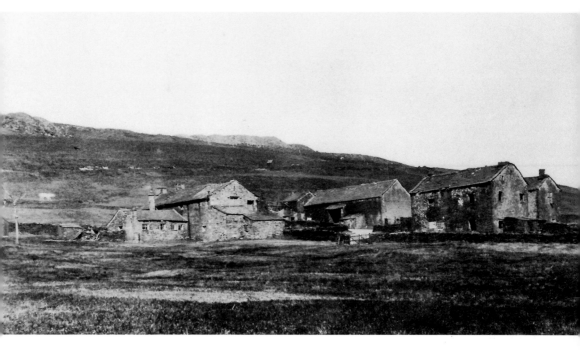

Holden Hall

Once the largest and grandest house in Haslingden, Holden Hall was the home of the Holden family for several hundred years. Following their departure in the eighteenth century, it became tenements and was demolished in 1902 when Haslingden Corporation built the cemetery. Some of the farm buildings remain.

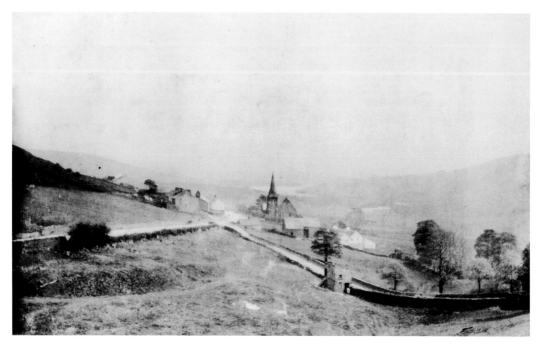

The Church that Moved

Following the construction of the Ogden Reservoir, which led to the depopulation of Grane, St. Stephen's Church was moved stone by stone in the 1920s to a new site at Three Lane Ends. Woodland now covers the bare fields of the 1900 photograph; which shows the centre of the village. The church has become an antiques centre and café.

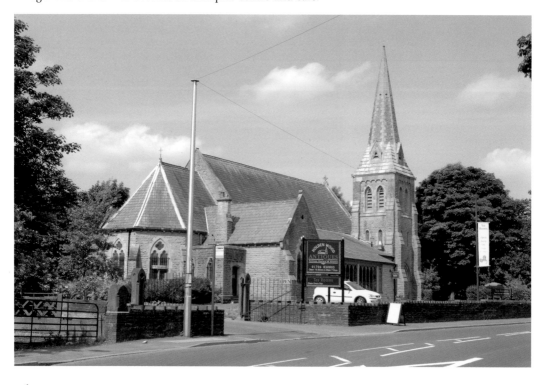

46

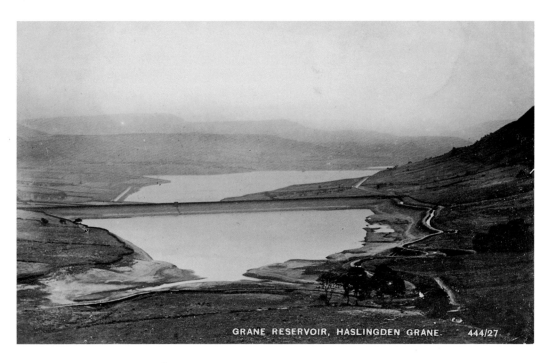

GRANE RESERVOIR, HASLINGDEN GRANE. 444/27

Water, Water, Everywhere

The Grane Valley, Haslingden's own 'Lake District', collects water for thirsty towns in south Lancashire. The 1918 picture shows the Calf Hey and Ogden Reservoirs in a landscape far bleaker than it is today. The ruins of a cotton mill were demolished to make way for the Ogden Reservoir. Today anglers cast their lines into its waters.

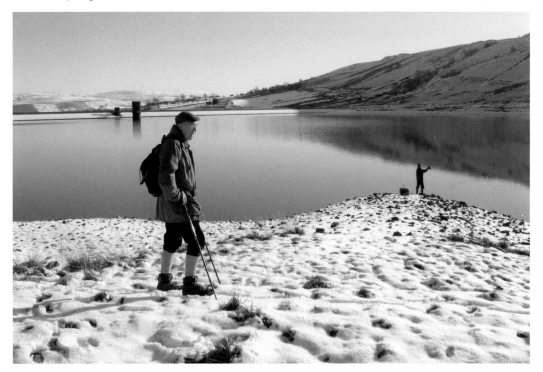

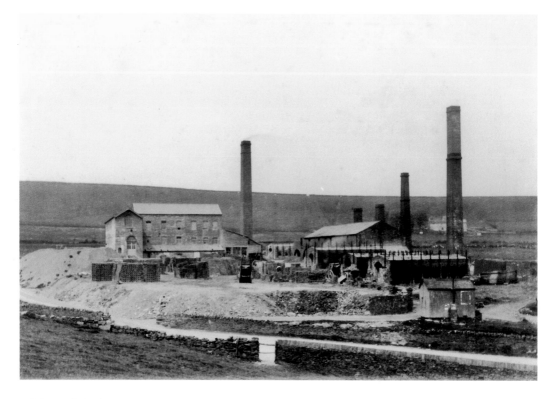

Bricks and Picnics

For a few years in the late nineteenth and early twentieth centuries, Clough Head was a busy corner of Grane when the Haslingden Grane Brick and Terra Cotta Company Limited built a brickworks there. The enterprise was short-lived and closed in 1903. The site was reclaimed in the 1980s and is now a popular spot for visitors to the valley.

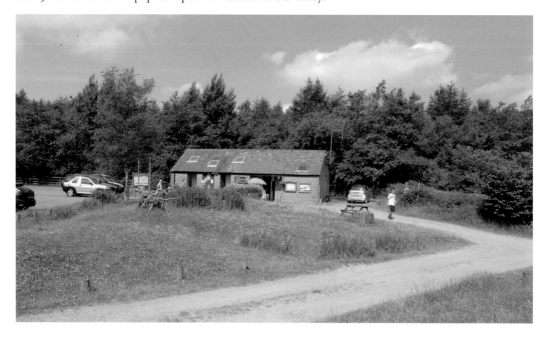

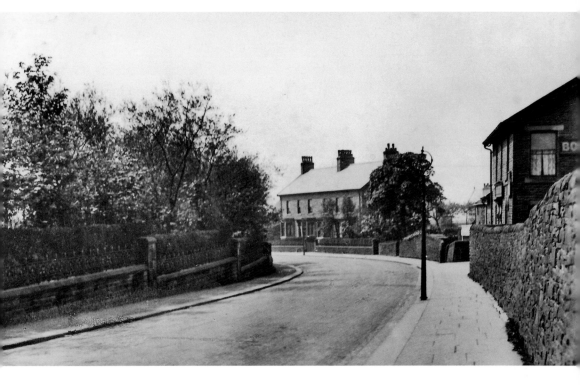

Lost to the by-pass

The Haslingden by-pass cut through the lower part of Victoria Park and necessitated the demolition of the Park Hotel and the adjoining houses at Knowl Gap, seen in the view from Deansgrave in the 1920s. The high wall was taken down to make room for bungalows.

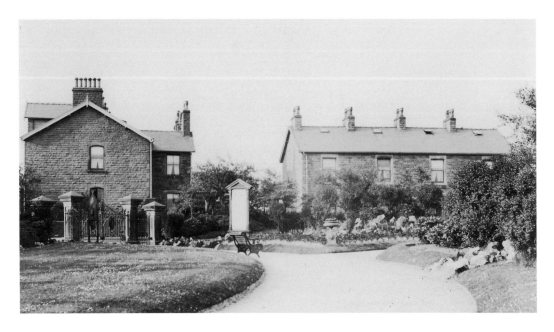

Regimented Flowers

Neat lines of flowers and 'Keep off the grass' signs were features of Victoria Park in the early years of the last century. The views towards the top entrance show how trees have grown to maturity.

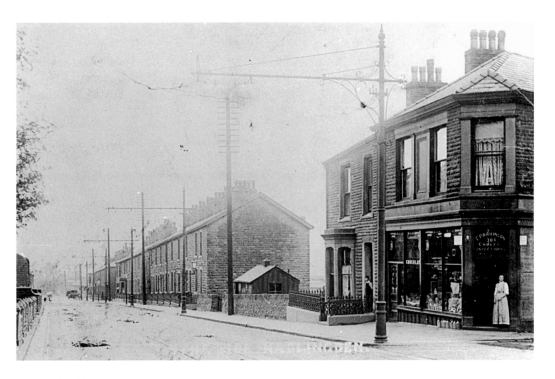

Sykeside

Sykeside, with its cotton mills and shops, was a thriving suburb of Haslingden until after the Second World War. The older photograph taken in about 1910 shows Thomas Parkinson's shop at the corner of Whiteley Street. It became a sub-post office following the First World War and is now a private house.

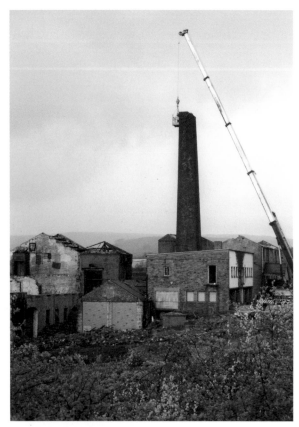

From Textiles to Tesco

A supermarket has replaced Sykeside Mill, which was demolished in 2002 following a number of fires. James Stott and Thomas Smith built the mill in 1836 to produce woollen goods. It switched to cotton some seventy years later. John Warburton Ltd ran the mill until 1970 and Wills Fabrics then used it until 1998. A garden centre followed, but had only a short life.

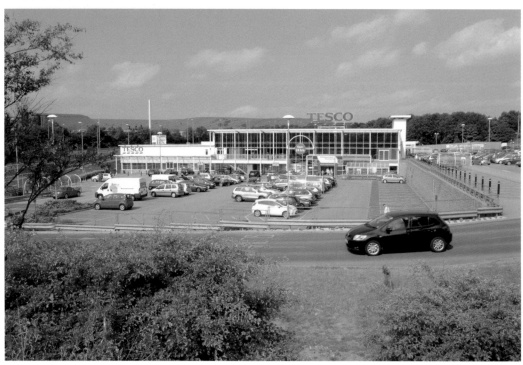

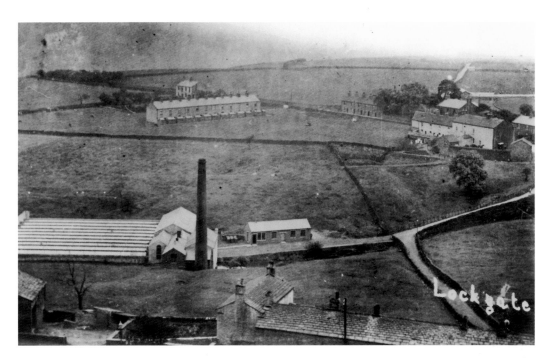

A Vanished Weaving Shed

The Haslingden by-pass and a group of flats now occupy the open fields seen in the older picture. Bent Street in the middle distance and the Woolpack on the right survive, but Lockgate cotton mill wove out in 1956. It was then a warehouse for a few years. The mill, built in 1872-73, had 300 looms.

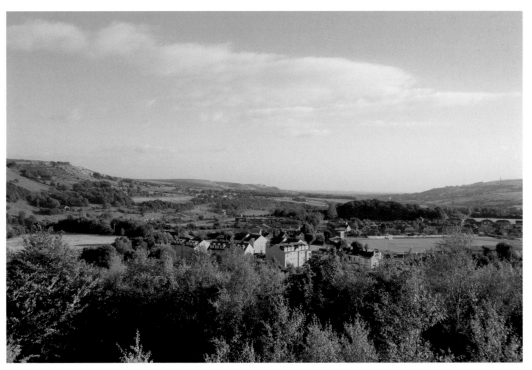

Fireworks at Bentgate

Haslingden Cricket Club has played its home games at Bentgate since 1853 and was a founder member of the Lancashire League in 1892. Professionals have included many of the world's best players, including Dennis Lillee, George Headley, Clive Lloyd, Andy Roberts and Vinoo Mankad. The old tearoom was replaced by a new clubhouse in the 1960s. As well as cricket, the club puts on a firework display on Bonfire Night.

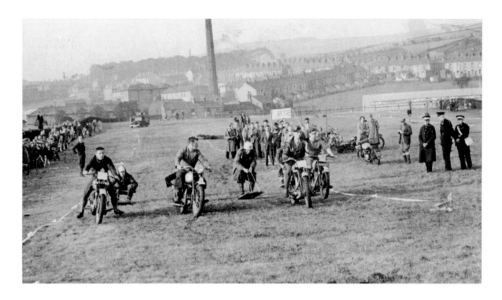

Sykeside Races

Rossendale Motorcycle and Light Car Club, which held its first events in the 1920s, was re-formed in 1950 and held gymkhanas at Sykeside in September, 1951 (pictured) and September, 1952. Thousands of people watched the races. In the background are Fields Road and Syke Mill (cotton), which ceased trading in 1982. When Haslingden Corporation decided to bring new industries into the town, the club's days were numbered. In 1956, Durie & Miller (now Interfloor) makers of carpet underlay, moved into a factory built by the Corporation. Lord Derby performed the opening ceremony; and the entrance to new estate was named Knowsley Road to commemorate his visit.

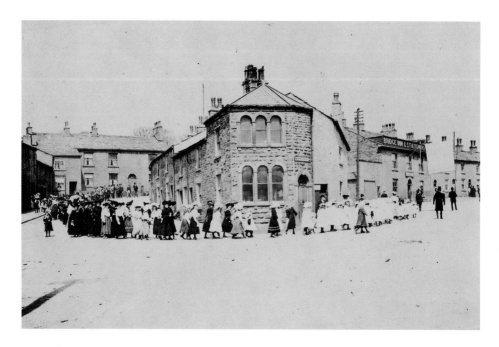

Ewood Bridge

The hamlet of Ewood Bridge has lost many of its buildings since the Sunday School scholars took part in a Whitsuntide procession in the early 1900s. The building in the foreground began life as a tollhouse for the turnpike road between Haslingden and Edenfield. The section to Bentgate originally ran behind the houses in Manchester Road. The present stretch with its easier gradient was opened in 1826.

CHAPTER 2

Helmshore

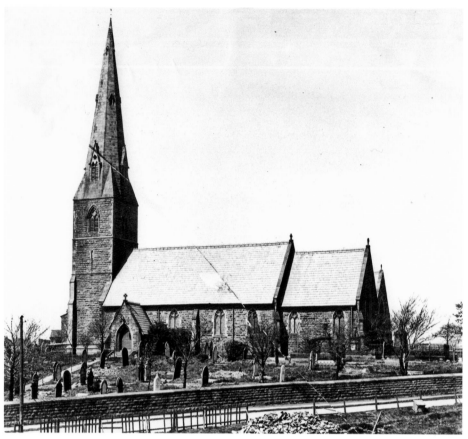

Musbury Church

Musbury Church in 1890, some thirty-eight years after it was built and seven years before its clock gave villagers the time. Many of the trees and shrubs were planted by Sunday school scholars, helped by Richard Gregson, the gardener employed by William Turner, the factory master, who paid for the building of the church and who was the first person to be buried in the churchyard.

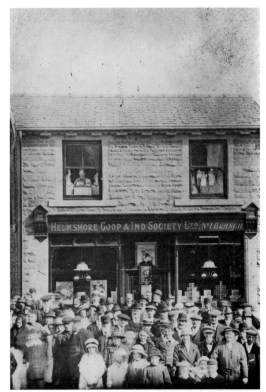

Shopping at the Co-op

Helmshore Co-operative Society, formed in 1861 and based in Holcombe Road, opened a branch opposite Musbury Church in 1916. After the society merged with its Haslingden neighbour in 1931, it became No. 14 branch of the larger body. When trading ceased, the building had several uses, most recently as a restaurant from 1987. The adjoining houses were completed in 2007.

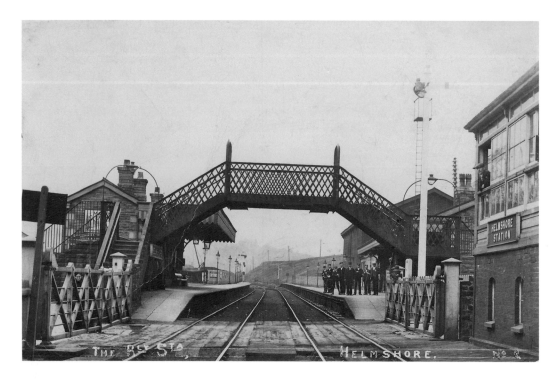

Helmshore Station

Helmshore railway station was a busy little halt on the Stubbins–Accrington line when the photograph above was taken in 1907. It closed in 1966, but was not demolished until 1985. The modern view was taken from a similar position with the old stationmaster's house on the left.

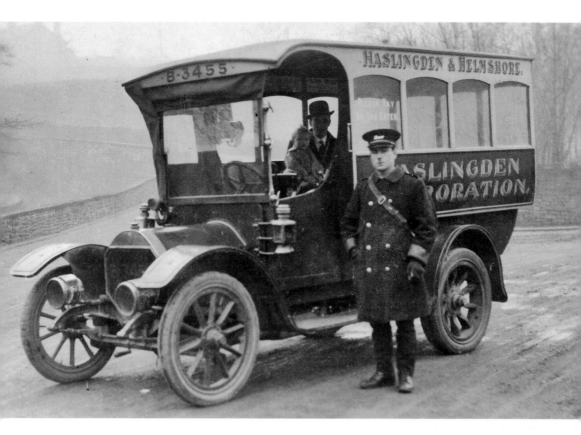

Buses at Bridge End

Haslingden Corporation ran one of the country's earliest one-man operated buses for a few months in 1919-20. It became known as The Whippet and is pictured at the bottom of Free Lane. The photograph below shows one of its successors in difficulties at the same place following the flood on July 18, 1964.

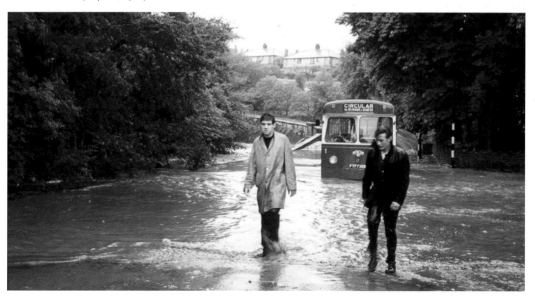

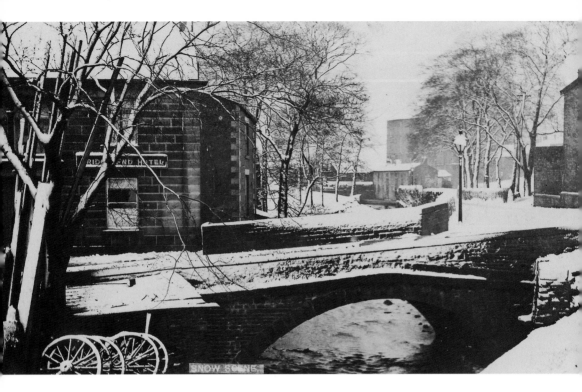

Station Road

Bowl Alley was the old name for Station Road, which runs alongside the River Ogden at Helmshore. Enthusiasts are thought to have played the ancient game of road bowls there. The photographs show the road on a snowy day in 1905 and during the floods following a terrific thunderstorm on 18 July, 1964.

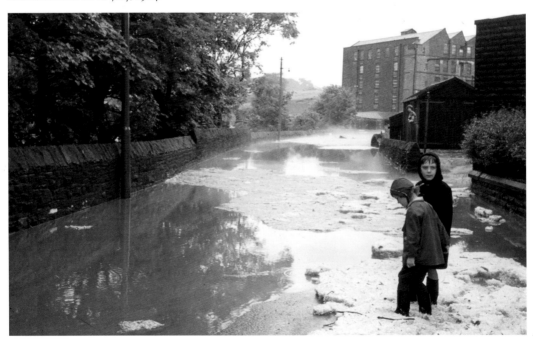

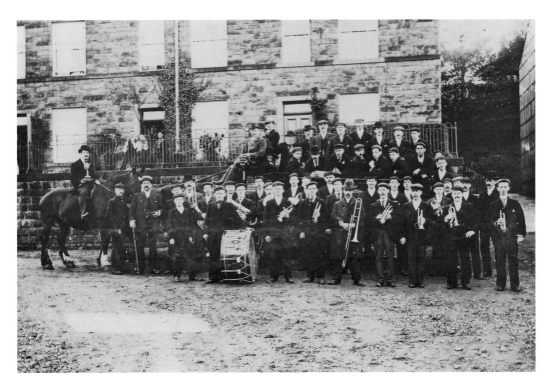

Helmshore Prize Band

Helmshore Brass Band, formed in 1872, added 'Prize' to its name when it came first at the Crawshawbooth contest in 1906. The bandsmen with the cup they won were photographed at Sunnybank on their return. Below: the band at Bridge End in 1972, when they headed a Sunday school procession. The band room, now a private house, is the building with the pale blue door.

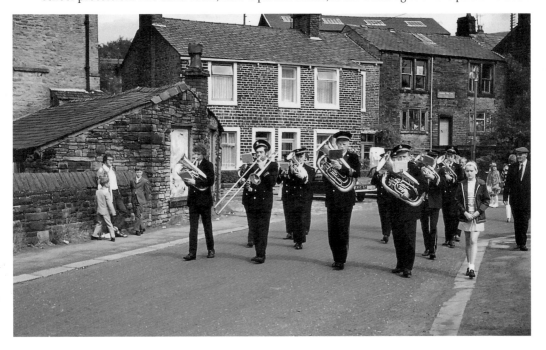

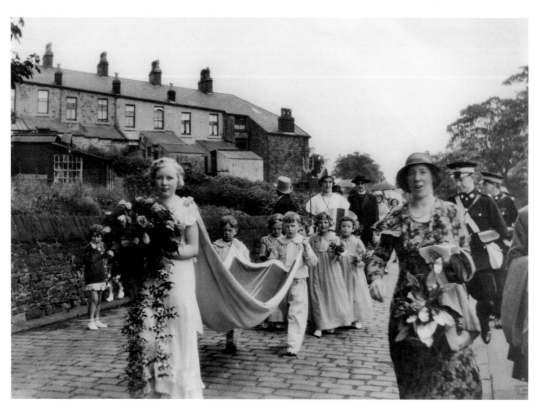

Bridge End

Bowl Alley in 1933 and 2010. The photograph above shows Mary Horrocks leading Springhill Methodist's Rose Queen procession. The land behind Elm Terrace was cleared in 2000 to make way for a new row of stone cottages.

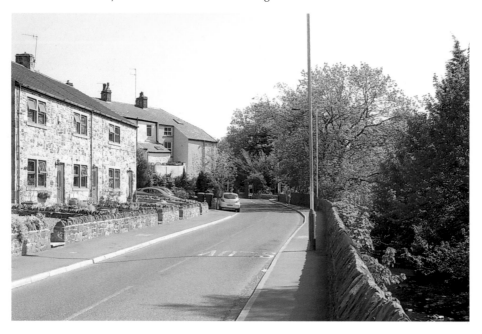

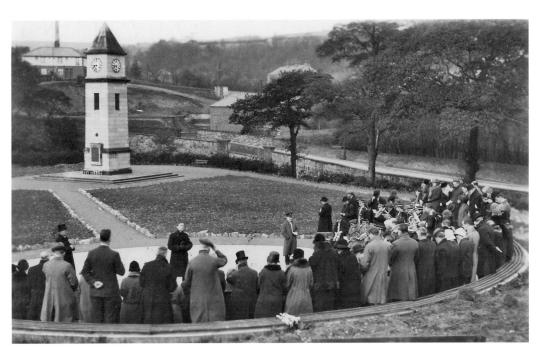

Thanksgiving Service
Following the First World
War, the three Helmshore
churches held a thanksgiving
service in the Memorial
Gardens on the first Sunday
in May. The picture from
the early 1920s shows the
Revd F. Humble (Primitive
Methodist) leading the
service. The top-hatted Vicar
of Musbury, the Revd A.
Winfield, is on the left. The
modern view is of the clock
tower from the riverside.

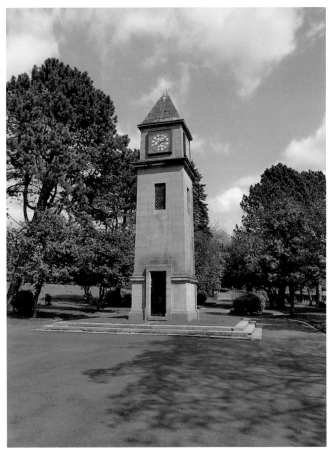

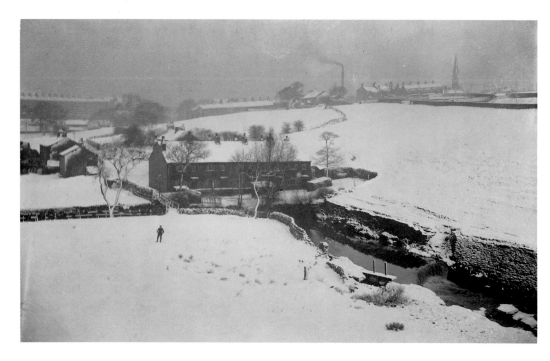

Snig Hole in the Snow

Snig Hole (a snig was a young eel) on a snowy day in 1905. The back-to-back cottages were built for people who worked in a woollen mill that stood in the field close by. Note the Ravenshore Mill weir and sluice gate on the right. The weir was washed away during a flood in the late 1940s. The footbridge was replaced in 1908.

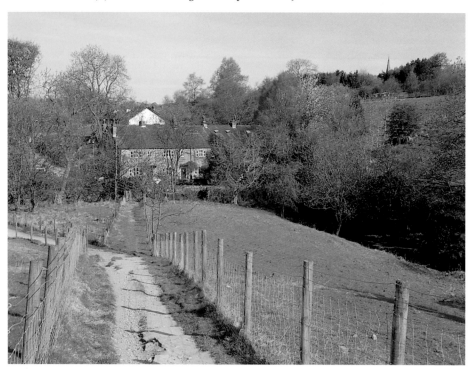

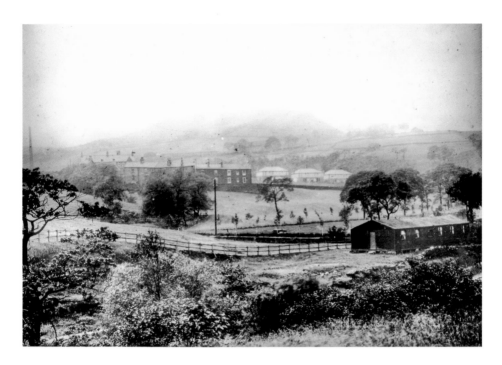

Snig Hole and Free Lane

The Tor and Free Lane seen from Snig Hole in 1923. Oliver Porritt, head of the village woollen firm, gave the shed in the foreground to Helmshore Prize Band, which practised there until 1933. Afterwards, the Blue Ribbon Club at Bridge End became the band room. The land between Free Lane and the river is now covered by allotments where Linda Doody is seen hard at work below.

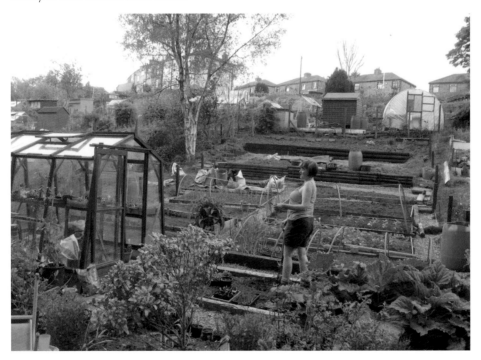

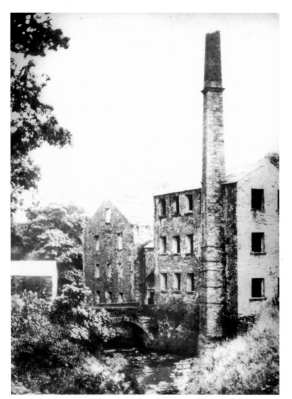

Old Mill by the Stream

The ruins of Ravenshore cotton mill in about 1890. Water from the Ogden drove a fulling mill on the site as early as the seventeenth century. A later mill and dye house were said in 1757 to be 'large and newly built'. Fulling (the thickening and cleaning of newly-woven woollen cloth) gave way to cotton spinning in the early 1800s, and weaving followed. The death of John Ashworth in 1877 led to the mill's closure. By then power was from an 18ft. 6in. wheel and a steam engine. When the buildings were demolished in 1899, the stone was used to build the river wall downstream from the railway viaduct.

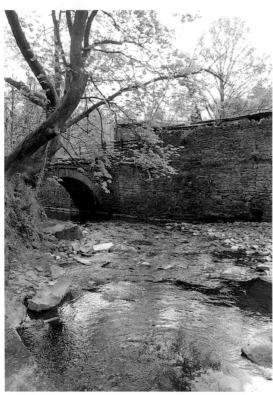

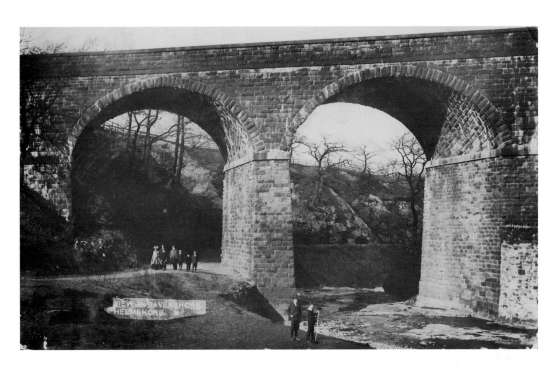

Ravenshore Viaduct

Though the last trains ran through Helmshore in 1966, the Ravenshore viaduct survives as a splendid relic of the Railway Age. The skew bridge was completed in time for the opening in 1848 of the East Lancashire Railway Company's line between Accrington and Stubbins Junction. The walk from Helmshore to Irwell Vale is one of the great delights of the district; and the rocky riverbed overlooked by the viaduct was once known as 'Little Blackpool' from the large number of children who bathed and paddled there.

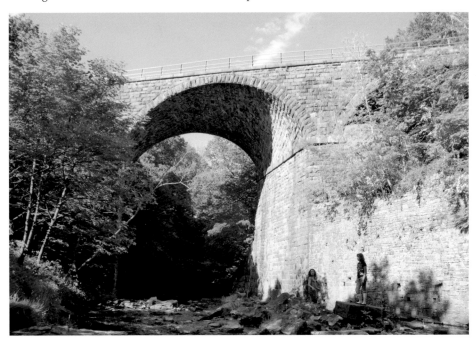

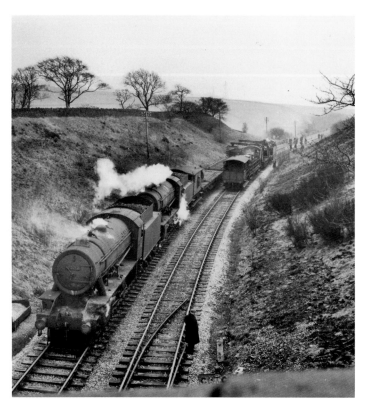

Where Two Trains Collided

Trees have colonised much of the railway track since the line closed in 1966. These views – the older one from 1952 – are from the lane between Ravenshore and Irwell Vale. Other sections are used by walkers and cyclists. The modern view shows the site of the district's greatest disaster. On 4 September, 1860, fifteen carriages broke loose from a train standing in Helmshore station, ran back and collided with another train approaching from Ramsbottom. Ten people died and more than fifty were injured.

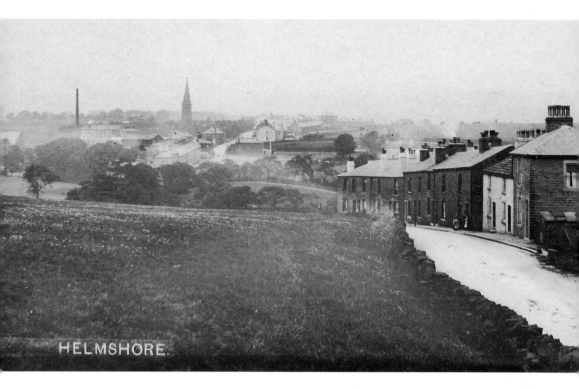

HELMSHORE.

The Village from Free Lane
Council houses, built in the 1920s, and private houses that came after the Second World War, now fill the field shown on the 1905 photograph.

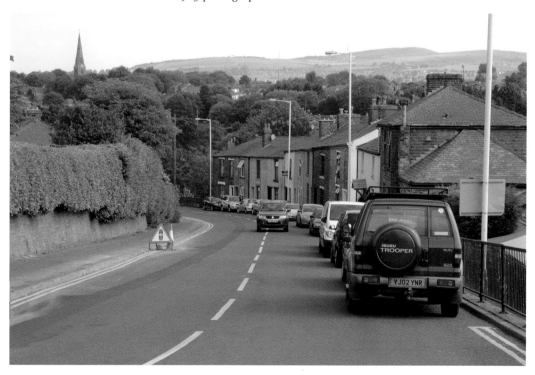

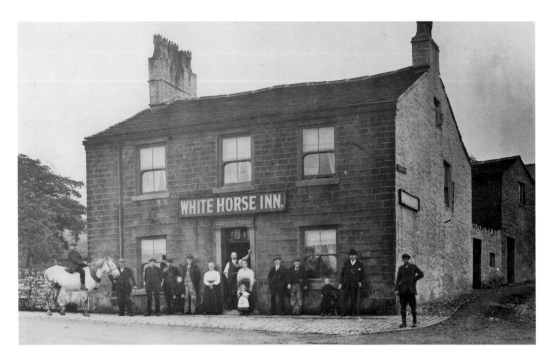

The White Horse

The White Horse, Helmshore's oldest hostelry, is now twice the size it was when the older photograph was taken in 1913. It was built in 1825 at the junction of Holcombe Road, the main road to Bury, and Stake Lane, the ancient highway to Bolton. The pub was extended in the 1950s and has since been a restaurant.

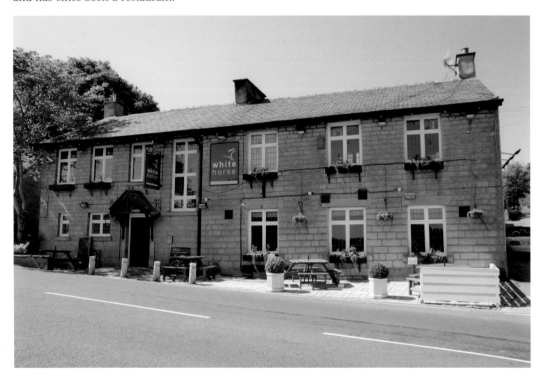

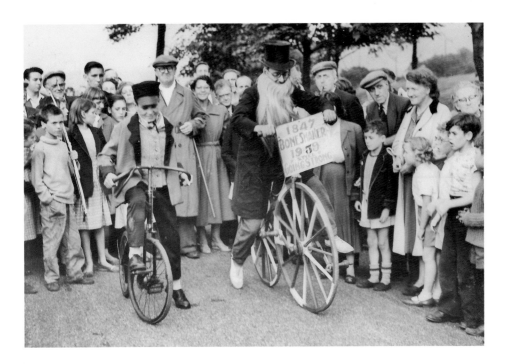

Alden Road

Travellers from Haslingden to Bolton in the days before wheeled traffic went along Alden Road, turned right at Robin Hood's Well and followed the moorland track to Hawkshaw. These pictures were taken just beyond the White Horse car park. The older one shows the start of an 'Old v New' bicycle race organised by Helmshore Local History Society in August, 1959. Peter Kay, aged twelve, easily beat Robert Sefton, riding a nineteenth-century Boneshaker owned by George Berry (holding walking stick) of Haslingden. On 31 May 2010, Jake Berry, newly-elected MP for Rossendale and Darwen, officially opened a section of the road that had been repaired and resurfaced at the expense of local residents.

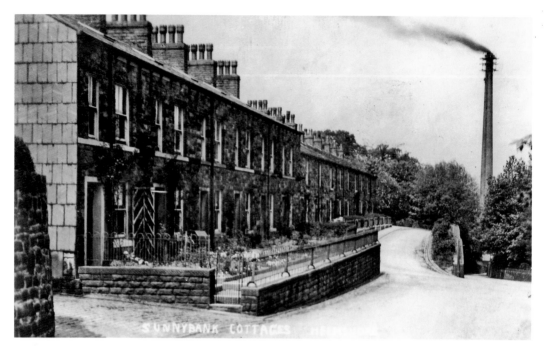

Sunnybank

Sunnybank cottages. The tall chimney of Sunnybank Mill smokes busily in the 1920s picture, indicating that the firm of Porritts & Spencer, which specialised in papermakers' felts and other industrial cloths, was not short of orders. The cottages were built for people who worked at the mill. The row furthest from the camera is on the site of the original Sunnybank Mill, built in 1798. The Porritts reused some of the masonry when building the cottages.

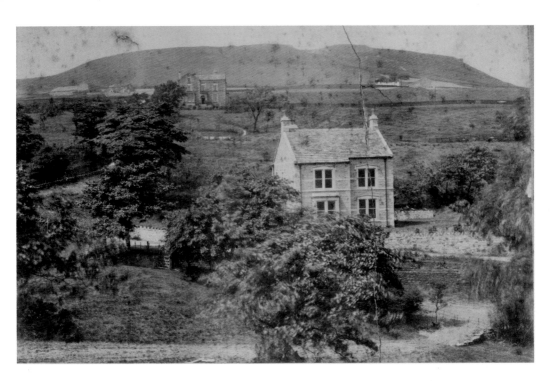

More Trees in Alden

Helmshore has gained many trees since Ivy Lodge was photographed soon after its completion in 1890. Ivy Lodge, which was extended in 1894, was built for William John Porritt Jnr., following his marriage; and was the later the home of J. H. Spencer, another director of Porritts & Spencer, the company that ran Sunnybank Mill.

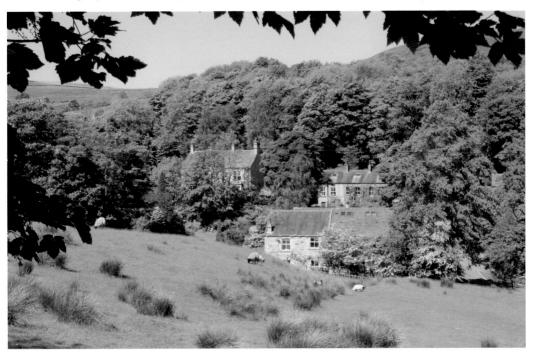

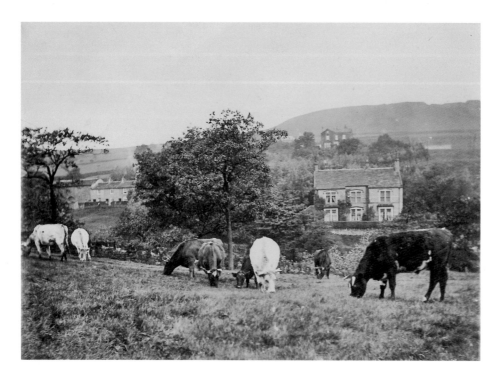

Back to Nature

Farming in Alden, old and new. The upper photograph shows the cattle of the Porritt family grazing in the fields near Ivy Lodge in about 1910. Below is Cronkshaw Fold Farm, now an environmental centre, which introduces 100 or more schoolchildren to rural life each week. They make friends with animals, study ponds and gardens; and in the wooden building, known as the Nature Detectives' HQ, use microscopes and other scientific equipment to see wonders invisible to the human eye.

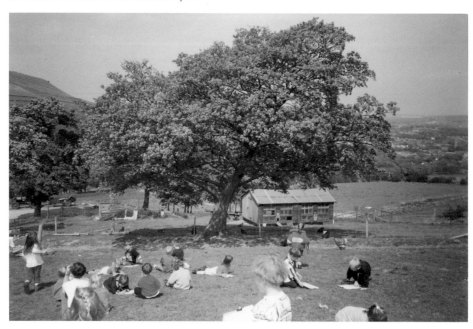

Stake Lane

Stake Lane, the ancient highway that led from Helmshore to Bolton, climbs out of the village to Robin Hood's Well before crossing the moor to Hawkshaw. The older picture dates from 1909; that below from 1976, when ramblers from St. Thomas's Church rested after the ascent.

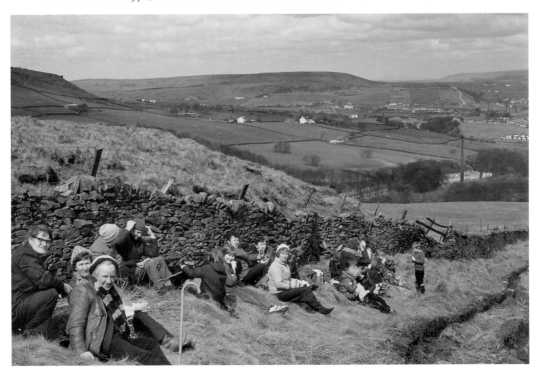

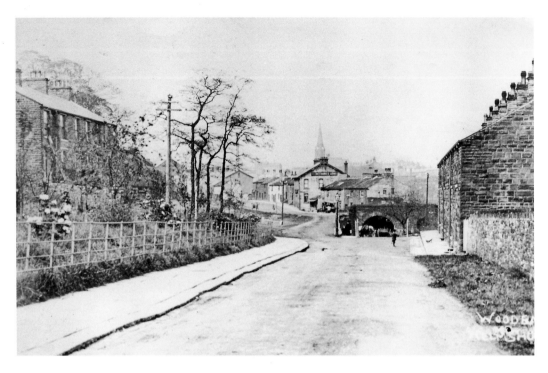

Woodbank

Woodbank is another part of Helmshore with far more trees than a century ago. The road bridge in the middle distance was built in 1881 after a great flood swept away a predecessor erected by the Elton and Blackburn Turnpike Trust. Just beyond it is the Mechanics' Arms, later the British Legion Club and now a private house.

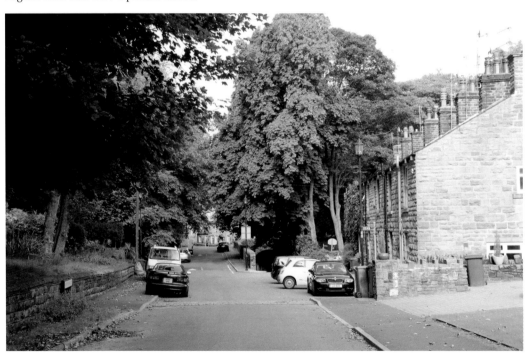

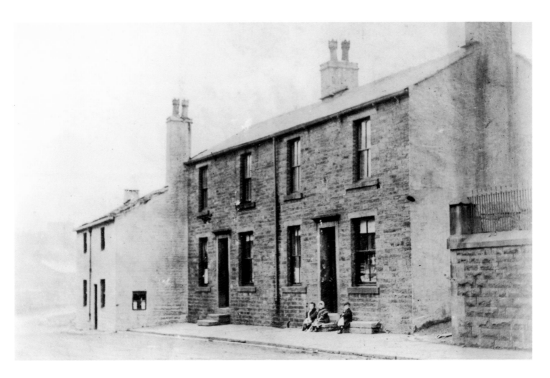

A Link with the Turnpike

The two cottages survive in Holcombe Road, but the old 'Bar House' was demolished in the 1960s. The Elton and Blackburn Turnpike Trust built the road after securing an Act of Parliament in 1810 and collected tolls from travellers. The house on the right was a shop in 1902, one of about thirty in the village at that time.

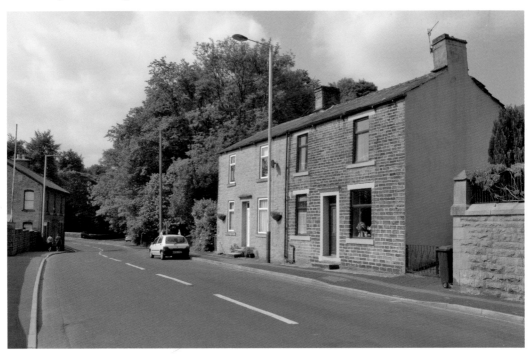

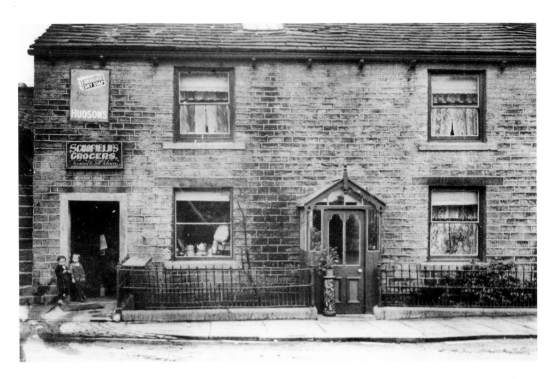

Hollinbank

Thomas Schofield, grocer and butcher, opened a shop in Hollinbank during the 1840s. Schofield Street ('Tommy Nook') is named after him. The business remained in the family until the 1930s. Later owners were Mr and Mrs Pilling and Mr and Mrs Kilgour. Since its closure in the 1970s, the building has been a private house. The building dates from about 1824. Christopher Cronkshaw, of Cronkshaw Fold, was the first person to live there.

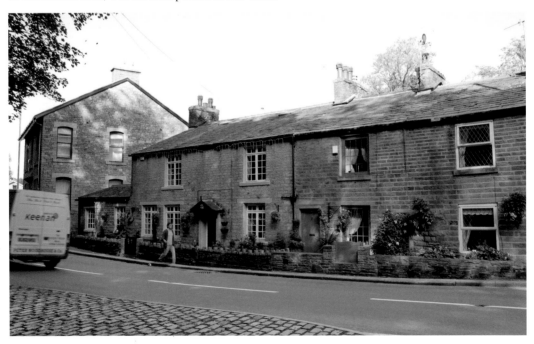

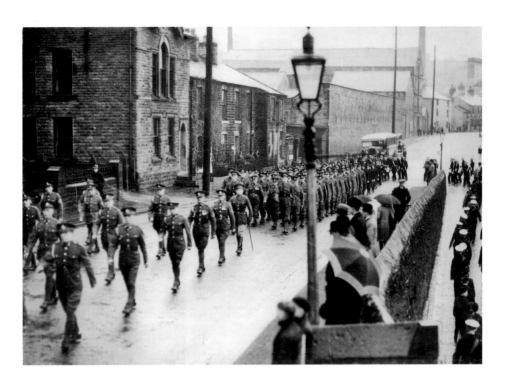

Holcombe Road

Following the dedication of the Royal British Legion standard at St. Thomas's Church on 29 October, 1933, Servicemen marched to the club in Hollinbank by way of Station Road and Holcombe Road. The soldiers are passing the Conservative Club (now a private house). A single-decker Haslingden Corporation bus waits near Middle Mill. Window-cleaner Danny Bones is seen crossing the road in the modern picture.

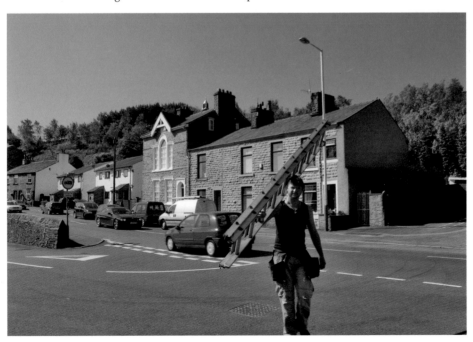

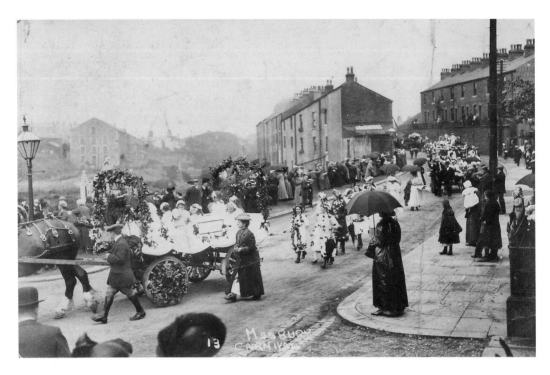

Rainy Days

Despite the rain, hundreds of people lined Holcombe Road to watch the Musbury Church carnival on 27 June 1914. The float nearest the camera was entitled 'Innocence'. Another shower in 2009 produced a rainbow.

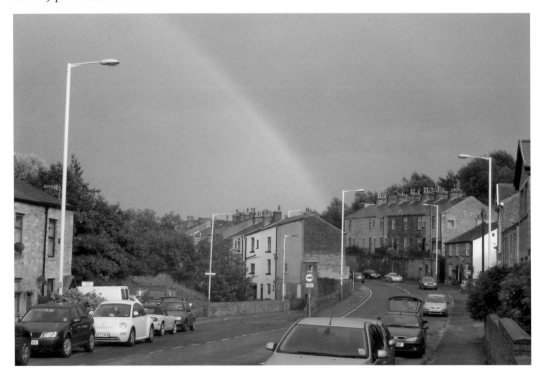

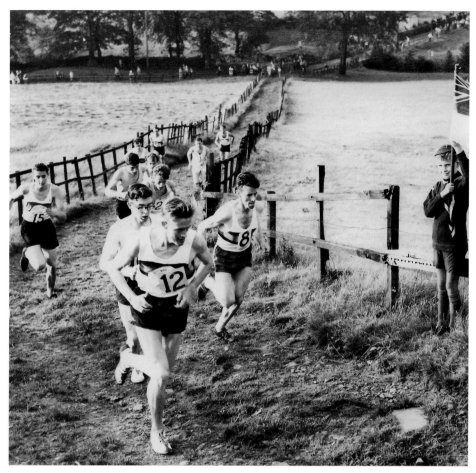

The Tor Mile

When Helmshore Local History revived the Tor Mile, on 23 June 1958, more than a thousand people came to watch senior and junior races from Barlow Terrace to the top of the hill and back again. The race had last been run as part of the peace celebrations in 1919. Now it is a more regular event. The photographs show the race in 1963 and 2009.

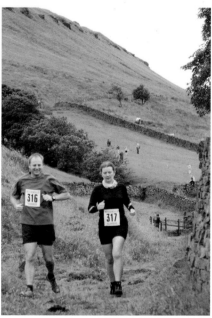

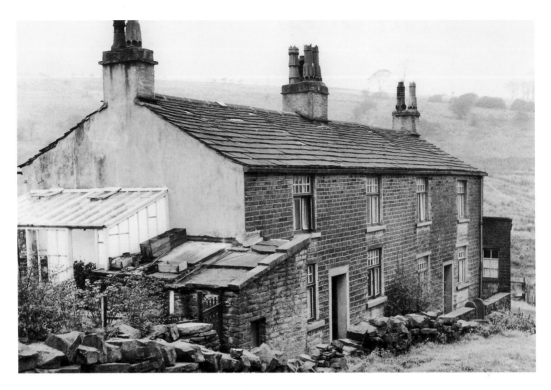

Carr Lane

A small settlement grew up at Carr Lane in Musbury where Thomas Worsick built a cotton mill, farmhouse and cottages in the 1820s. More houses were added in 1841 and they are pictured above in 1960. The mill was badly damaged by fire in 1890 and was demolished just after the First World War.

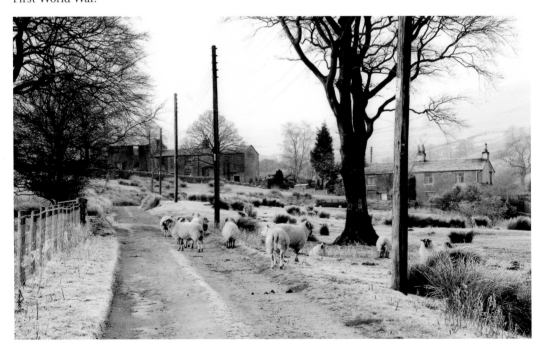

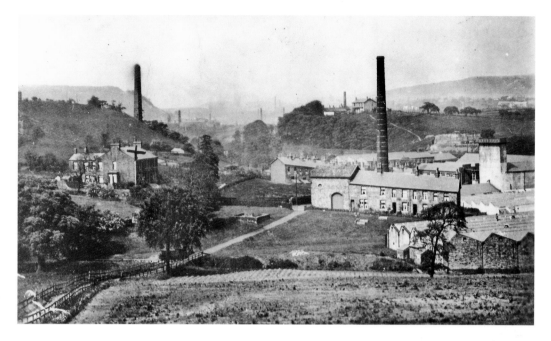

Silent Sentinels

The chimneys of Higher Mill (left) and Park Mill dominate the middle ground of the view from Higher Hollin Bank. They have long ceased to pour out black smoke, but unlike the distant chimneys they frame in the picture from the early 1920s, they stand as silent survivors from the age of industry. The older photograph was taken shortly before the new road was laid out across the fields to Carr Lane. Masonry from Carrs Mill was used to build the road. The project was promoted by the mill-owning Porritts to provide work for men who had served in the First World War and who were unemployed.

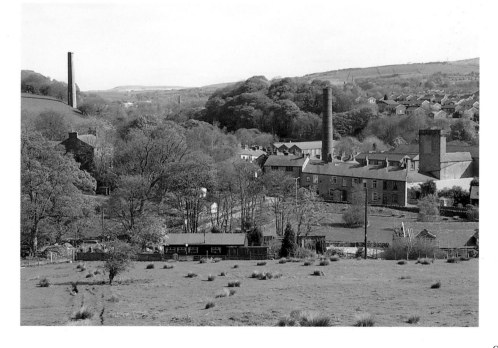

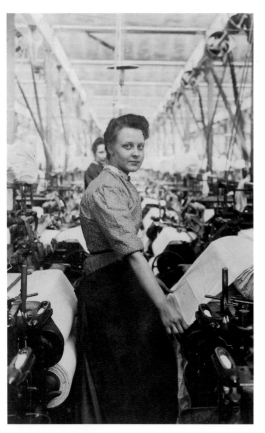

Prosperity from the Loom

The contribution of weaving to Helmshore's growth and prosperity cannot be overstated. From the sixteenth century, the handloom had a place in most cottages, where villagers wove woollen cloth both for their own use and for sale in often distant markets. Weavers added cotton when it penetrated the Pennine valleys, and the sound of the handloom was heard until the 1860s. Power looms appeared in the 1820s and weaving sheds became a feature of local life. Today the only looms in the village are at Contex Weaving in Park Mill, where Anna Benson and Neil Warburton have built an international reputation as specialists in reproduction fabrics. English Heritage, the National Trust and the Royal Palaces look to Helmshore when they need to replace. The older picture shows Mary Hannah Walsh at Middle Mill in 1906.

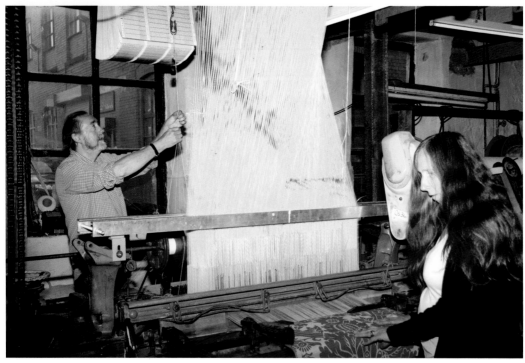

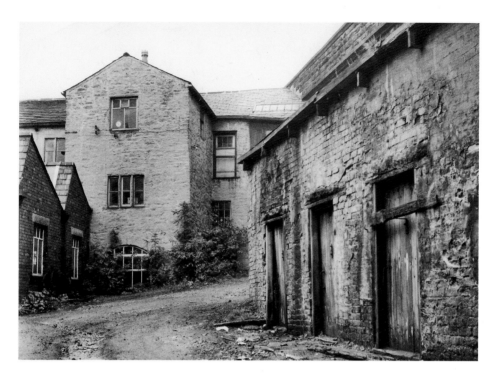

From Mill to Museum

Before it became a museum, Higher Mill, built in 1789, worked for almost two centuries fulling and finishing woollen cloth. For much of that time it relied on water power. The older photograph, taken in the 1960s, shows a modern brick extension and sulphur houses on the right. Children with whooping cough were put in them to inhale the fumes. Helmshore Local History Society led a successful campaign to preserve the mill, its waterwheel and historic machines when its working life ended. It is now run by Lancashire Museums Service.

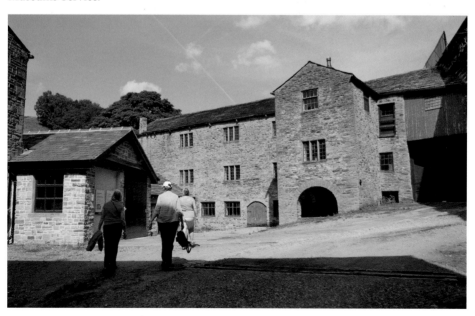

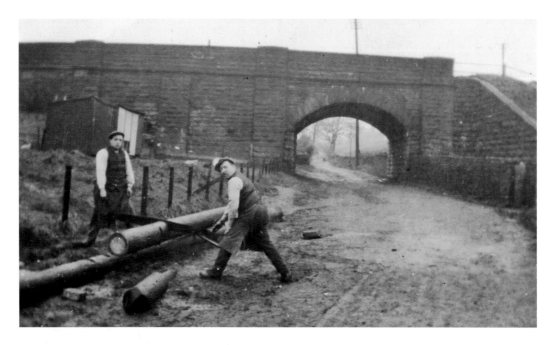

Gregory Fold

The lower part of Gregory Fold Lane was dominated by the railway bridge when a photographer snapped the village blacksmith Sam Egerton (right) and his striker Tom McQuilton sawing a telegraph pole in 1917. Sam's smithy was next to the river at the bottom of the lane. Since the war, the lane has seen many changes. From the school it has become an access road to the estates; the middle section has been absorbed into gardens, and the lower part is now a much-used footpath. The lower photograph was taken during the 1977 Silver Jubilee celebrations.

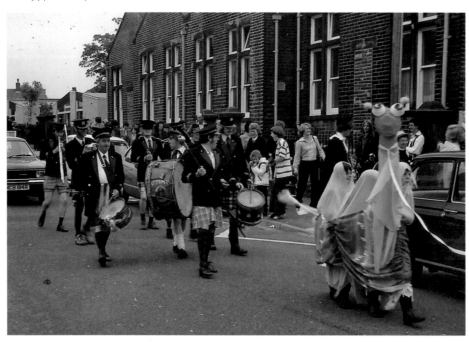

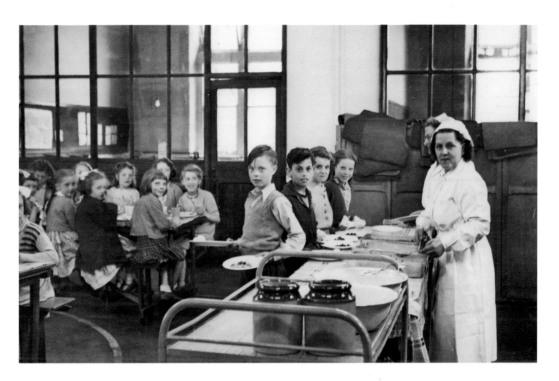

School Meals

Since they were first served during the Second World War, school meals have enjoyed a high reputation at Helmshore County Primary School. The older picture was taken in the 1947; and it was business as usual sixty years later.

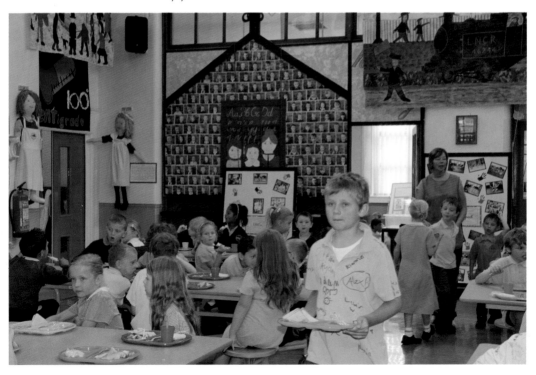

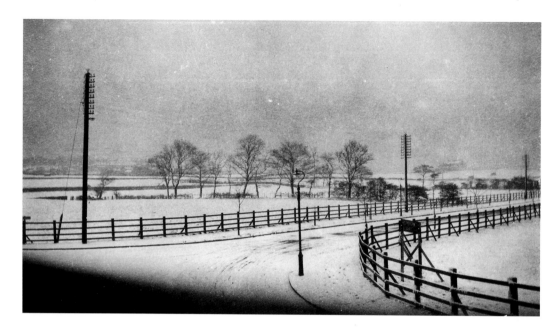

Big Changes in Broadway

The area near the junction of Broadway and Helmshore Road has seen huge changes since the older picture was taken in 1933. Haslingden Corporation built Broadway during the previous two years under a government scheme to help the unemployed. It provided a wider, straighter link to Manchester Road than the old 'Dow Lane'. This was a former turnpike road with a toll house in the middle, where the High School now stands. Private Lane, alongside the cricket club, is a remnant of the old lane. Council houses, shops and schools advanced into the meadows on both sides of Broadway after the Second World War.

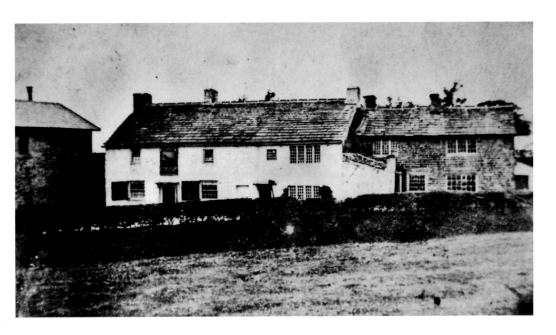

The First Bay Horse
The original Bay Horse Inn at Flaxmoss more than a century and a half ago. Rose Cottage stands in its place. The present Bay Horse at the junction of Helmshore Road and Grane Road was built in 1858-9, and the licence was transferred from the old building, which had been bought by Thomas Smith, of Turfcote. He later demolished it to make way for an entrance to his mansion. Smith's son, Thomas Kay Smith, took the photograph.

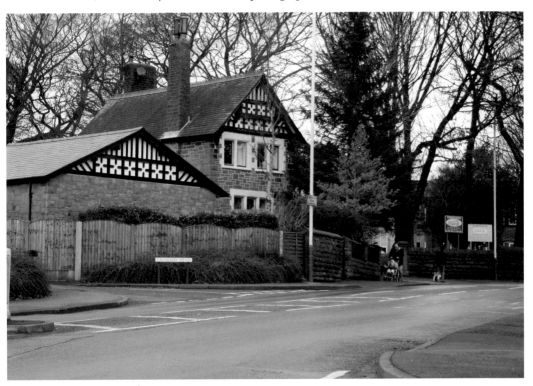

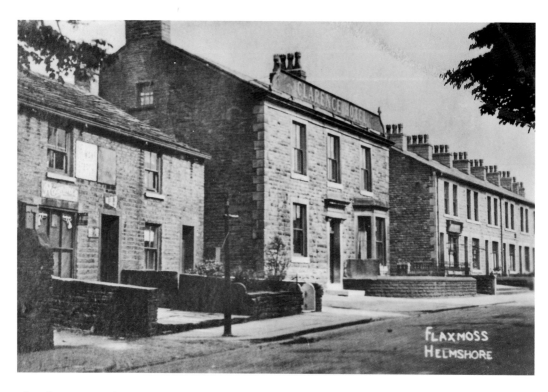

The Clarence Hotel

Flaxmoss has lost the cottage and shop on the left of the old picture, but the Clarence Hotel, built in the 1860s, still does good business though it, too, has seen a few changes.

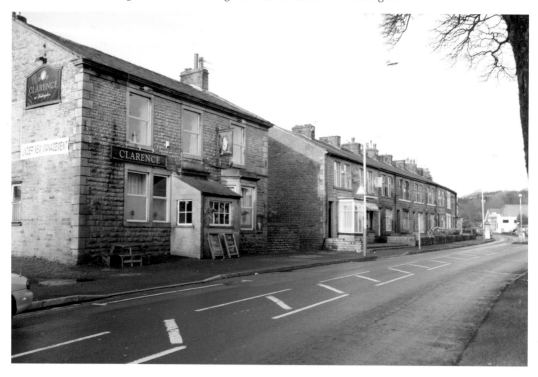

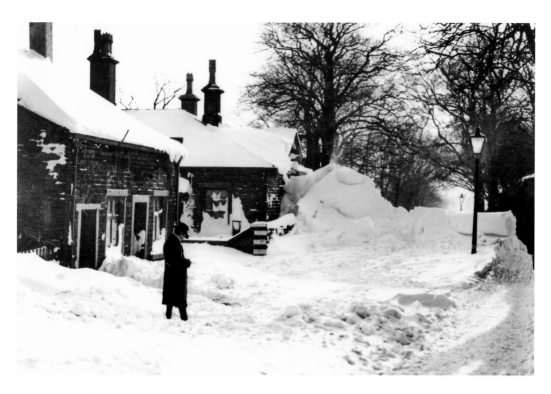

A Record Snowfall

Haslingden is believed to hold the English record for the heaviest fall of snow in 24 hours. This was in January, 1940, when huge drifts, like this one at Helmcroft, reached the tops of houses, and blocked roads and the railway for several days. The average depth of snow was put at about three feet. Local artist Michael Laffy is seen making a sketch of the scene.

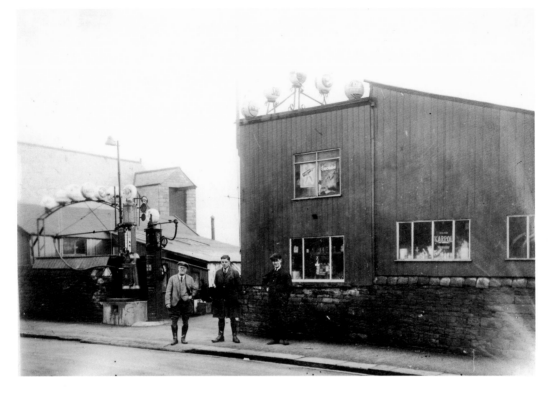

Flaxmoss Garage
Members of the Moorhouse family outside their garage in Flaxmoss in the 1930s. The Co-operative Society store, now a beauty salon, is in the background. The old wooden building was replaced by the present Jubilee Garage by Bill Grimshaw in 1980. He is pictured below filling up with petrol when traffic on Helmshore Road was much lighter than it is today.

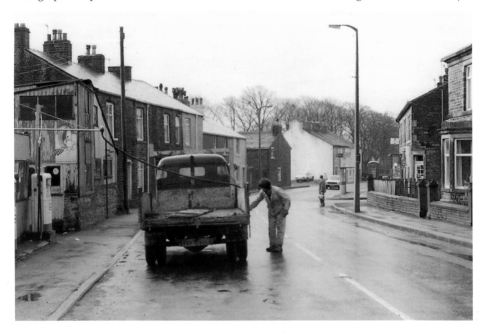

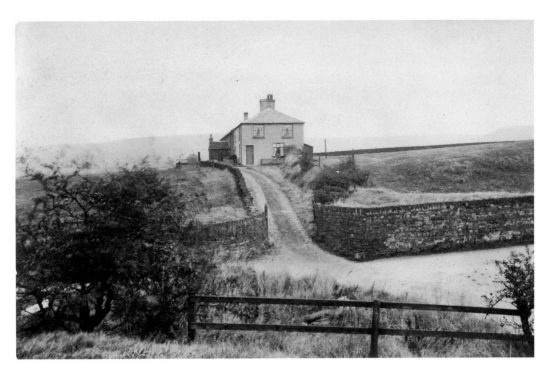

Rossendale Golf Club

Rossendale Golf Club, founded in 1903, used Ewood Out Barn (now demolished) as its first club house. It bought Ewood Lane Head Farm in 1912 and this was the club's headquarters until the present building was opened on 21 April, 2000.

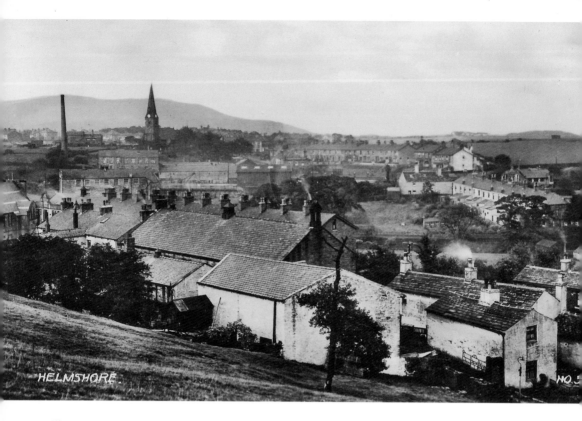

Village View

Helmshore from Hollinbank in the early 1930s. The cottage bottom right was built in about 1841 as a wheelwright's shop, but was later converted into a house.